T0198954

An Analysis of

Michael R. Gottfredson and Travis Hirschi's

A General Theory of Crime

William J. Jenkins

Published by Macat International Ltd
24:13 Coda Centre, 189 Munster Road, London SW6 6AW.

Distributed exclusively by Routledge
2 Park Square, Milton Park, Abingdon, Oxon OX14 4RN
711 Third Avenue, New York, NY 10017, USA

Routledge is an imprint of the Taylor & Francis Group, an informa business

www.macat.com
info@macat.com

Cataloguing in Publication Data
A catalogue record for this book is available from the British Library.
Library of Congress Cataloguing-in-Publication Data is available upon request.
Cover illustration: Etienne Gilfillan

ISBN 978-1-912303-58-8 (hardback)
ISBN 978-1-912128-71-6 (paperback)
ISBN 978-1-912282-46-3 (e-book)

Notice
The information in this book is designed to orientate readers of the work under analysis,
to elucidate and contextualise its key ideas and themes, and to aid in the development
of critical thinking skills. It is not meant to be used, nor should it be used, as a
substitute for original thinking or in place of original writing or research. References and
notes are provided for informational purposes and their presence does not constitute
endorsement of the information or opinions therein. This book is presented solely for
educational purposes. It is sold on the understanding that the publisher is not engaged
to provide any scholarly advice. The publisher has made every effort to ensure that
this book is accurate and up-to-date, but makes no warranties or representations with
regard to the completeness or reliability of the information it contains. The information
and the opinions provided herein are not guaranteed or warranted to produce particular
results and may not be suitable for students of every ability. The publisher shall not be
liable for any loss, damage or disruption arising from any errors or omissions, or from
the use of this book, including, but not limited to, special, incidental, consequential or
other damages caused, or alleged to have been caused, directly or indirectly, by the
information contained within.

CONTENTS

THE MACAT LIBRARY

The Macat Library is a series of unique academic explorations of seminal works in the humanities and social sciences – books and papers that have had a significant and widely recognised impact on their disciplines. It has been created to serve as much more than just a summary of what lies between the covers of a great book. It illuminates and explores the influences on, ideas of, and impact of that book. Our goal is to offer a learning resource that encourages critical thinking and fosters a better, deeper understanding of important ideas.

Each publication is divided into three Sections: Influences, Ideas, and Impact. Each Section has four Modules. These explore every important facet of the work, and the responses to it.

This Section-Module structure makes a Macat Library book easy to use, but it has another important feature. Because each Macat book is written to the same format, it is possible (and encouraged!) to cross-reference multiple Macat books along the same lines of inquiry or research. This allows the reader to open up interesting interdisciplinary pathways.

To further aid your reading, lists of glossary terms and people mentioned are included at the end of this book (these are indicated by an asterisk [*] throughout) – as well as a list of works cited.

Macat has worked with the University of Cambridge to identify the elements of critical thinking and understand the ways in which six different skills combine to enable effective thinking.
Three allow us to fully understand a problem; three more give us the tools to solve it. Together, these six skills make up the **PACIER** model of critical thinking. They are:

ANALYSIS – understanding how an argument is built
EVALUATION – exploring the strengths and weaknesses of an argument
INTERPRETATION – understanding issues of meaning

CREATIVE THINKING – coming up with new ideas and fresh connections
PROBLEM-SOLVING – producing strong solutions
REASONING – creating strong arguments

To find out more, visit **WWW.MACAT.COM.**

CRITICAL THINKING AND *A GENERAL THEORY OF CRIME*

Primary critical thinking skill: REASONING
Secondary critical thinking skill: INTERPRETATION

Michael R. Gottfredson and Travis Hirschi's 1990 *General Theory of Crime* is a classic text that helped reshape the discipline of criminology. It is also a testament to the powers of clear reasoning and interpretation. In critical thinking terms, reasoning is all about presenting a solid and persuasive case – and as many people instinctively understand, the most persuasive reasoning is that which manages to find a single, simple hook. In Gottfredson and Hirschi's case, the hook was what has come to be known as the "self-control theory of crime," the idea, in other words, that tendency to commit crime is directly related to an individual's level of self-control. While the dominant schools of thought of the time tended to focus on complex environmental factors, with little attempt to unify different theories, Gottfredson and Hirschi sought to interpret things so as to provide a single overarching concept. Moreover, while other theories helped explain specific types of crime, self-control could, in Gottfredson and Hirschi's view, be seen as a root cause for all crime in all contexts. While such simplicity inevitably attracted as much criticism as agreement, subsequent studies have provided real-world corroboration for *General Theory*'s persuasive reasoning.

ABOUT THE AUTHORS OF THE ORIGINAL WORK

Born in 1951, **Michael R. Gottfredson** is a well-respected criminologist who has held a number of important positions in several American universities, even serving as president of the University of Oregon from 2012 to 2014. Born in 1935, **Travis Hirschi** is also a criminologist, and is currently emeritus professor of sociology at the University of Arizona. His graduate student dissertation was published as a book, *Causes of Delinquency* (1969), and has been recognized as an important contribution to his field. The authors met and began collaborating while Gottfredson was a graduate student at the State University of New York at Albany. This cooperation eventually led to *A General Theory of Crime*, a work published in 1990 that is still considered important in criminology today.

ABOUT THE AUTHOR OF THE ANALYSIS

Dr William Jenkins holds a PhD in psychology from the University of Michigan. He is currently co-chair of the Department of Psychology at Mercer University.

ABOUT MACAT

GREAT WORKS FOR CRITICAL THINKING

Macat is focused on making the ideas of the world's great thinkers accessible and comprehensible to everybody, everywhere, in ways that promote the development of enhanced critical thinking skills.

It works with leading academics from the world's top universities to produce new analyses that focus on the ideas and the impact of the most influential works ever written across a wide variety of academic disciplines. Each of the works that sit at the heart of its growing library is an enduring example of great thinking. But by setting them in context – and looking at the influences that shaped their authors, as well as the responses they provoked – Macat encourages readers to look at these classics and game-changers with fresh eyes. Readers learn to think, engage and challenge their ideas, rather than simply accepting them.

'Macat offers an amazing first-of-its-kind tool for
interdisciplinary learning and research. Its focus on works
that transformed their disciplines and its rigorous approach,
drawing on the world's leading experts and educational institutions,
opens up a world-class education to anyone.'

Andreas Schleicher
Director for Education and Skills, Organisation for Economic
Co-operation and Development

'Macat is taking on some of the major challenges in university
education … They have drawn together a strong team of active
academics who are producing teaching materials that are
novel in the breadth of their approach.'

Prof Lord Broers,
former Vice-Chancellor of the University of Cambridge

'The Macat vision is exceptionally exciting. It focuses
upon new modes of learning which analyse and explain seminal texts
which have profoundly influenced world thinking and so social and
economic development. It promotes the kind of critical thinking
which is essential for any society and economy.
This is the learning of the future.'

Rt Hon Charles Clarke, former UK Secretary of State for Education

'The Macat analyses provide immediate access to the critical
conversation surrounding the books that have shaped their
respective discipline, which will make them an invaluable resource
to all of those, students and teachers, working in the field.'

Professor William Tronzo, University of California at San Diego

WAYS IN TO THE TEXT

KEY POINTS

- Michael R. Gottfredson and Travis Hirschi are American criminologists*—scholars of how and why crimes are committed.

- In their book, *A General Theory of Crime* (1990), Gottfredson and Hirschi introduce the self-control theory* of crime, saying that people with poor self-control are more likely to break the law than are people with normal or high levels of self-control.

- *A General Theory of Crime* offers a simple, universal theory to explain why all kinds of crimes happen.

Who Are Michael R. Gottfredson and Travis Hirschi?

Michael R. Gottfredson (born 1951) received his BA from the University of California at Davis and his PhD from the State University of New York at Albany. He is a well-respected criminologist who has held significant leadership positions in several American universities. He served as executive vice chancellor at the University of California at Irvine from 2000 to 2012, and as president of the University of Oregon from 2012 to 2014. Gottfredson is currently professor of criminology, law, and society at the University of California at Irvine.

Like Gottfredson, Travis Hirschi (born 1935) is an American criminologist. He received his BA and MA from the University of Utah, and his PhD from the University of California at Berkeley. Before the publication of *A General Theory of Crime*, Hirschi was best known for his 1969 book, *Causes of Delinquency*. He has served on the faculty of a number of American universities, and he is currently emeritus professor of sociology at the University of Arizona.

Gottfredson and Hirschi first met at the State University of New York at Albany. At the time, Gottfredson was a graduate student and Hirschi was a visiting professor in the School of Criminal Justice. They collaborated on a variety of projects, and would continue to work together over the next several decades. Their crowning achievement was the publication of *A General Theory of Crime* in 1990.

What Does *A General Theory of Crime* Say?

In *A General Theory of Crime*, Gottfredson and Hirschi, introduce a new theory of crime, called the "self-control theory," to the criminology community. The theory suggests that people with low levels of self-control are more likely to commit crimes than people with normal and high levels, and that criminologists can, then, predict crime by measuring levels of self-control. Gottfredson and Hirschi were prompted to develop this theory because they found other explanations for why people commit crimes to be unsatisfactory. The authors said popular theories that people break the law because of environmental factors—social or economic status, for example—did not take into account human behavior and human nature.

Gottfredson and Hirschi argue that self-control forms early in a person's life and is heavily influenced by a child's relationship with his or her parent. A person's level of self-control, they claim, remains fairly stable after it is formed.

To support their arguments, Gottfredson and Hirschi discuss the work of several influential philosophers, such as the Italian philosopher

and criminologist Cesare Beccaria,* the English philosopher Jeremy Bentham,* and the British philosopher Thomas Hobbes.* Beccaria studied the relationship between crime and punishment. Bentham is noted for promoting utilitarianism,* the philosophy that the best action is the one that causes the most overall good. Hobbes is known for his discussion of the social contract—the idea that individuals give up certain rights to live peaceably in groups.

The three philosophers argue that behavior is motivated by the desire to experience pleasure and avoid pain, an argument that underpins self-control theory. According to Gottfredson and Hirschi this principle defines crime: criminals are willing to use force or fraud to avoid pain and experience pleasure. The two authors explain crime, then, by focusing on the individual's motivations and actions, rather than the environment.

One benefit of their theory, the authors argue, is that it helps explain all types of crime in the same way. While each of a number of disciplines had previously influenced the field of criminology, their isolation in different study areas meant that no unified theory of crime existed.

Gottfredson and Hirschi wanted to present a comprehensive theory that future criminologists could build on, and to this end, the book also includes a few recommendations for further research and for future policies. The authors argue, for example, that self-control theory can be researched in less costly and less complex ways than other, popular contemporary research designs. They also claim that self-control theory will help policymakers make policies that effectively deter crime. And there is no doubt that understanding the role of self-control in crime allows for the formulation of more useful social policies to prevent it.

Self-control theory was a major departure from the dominant school of thought in criminology, positivism,* which asserts that people break the law because of external factors beyond their control.

As a consequence, self-control theory has come under a great deal of critical scrutiny to determine whether the theory is valid.

In spite of the criticism it has received, research has generally supported Gottfredson and Hirschi's basic assertions. Today, it is one of the most cited texts in the field, and it continues to offer insight into why crimes are committed and to help criminologists better understand crime generally.

Why Does *A General Theory of Crime* Matter?

A General Theory of Crime is one of the most important texts in the recent history of criminology. Gottfredson and Hirschi claim that the theory explains why crimes are committed, and they demonstrate how the theory accounts for the existing data on crime.

The book offers insight into the development of a scientific theory and demonstrates the importance of collecting and interpreting data using the scientific process. It also shows how important it is for public policies to be based on science. Even those not interested in criminology itself would benefit from reading about these concepts.

Gottfredson and Hirschi use language that is easy to understand and widely accessible. When they use technical terms, they make sure to explain them in full. They also give plenty of context for self-control theory: for example, they provide a brief history of criminology itself so that readers can see how the ideas in *A General Theory of Crime* fit into the field's evolution.

While self-control theory itself is appealing because of its logic, elegance, and simplicity, it violates some of criminology's most popular assumptions. This has led, understandably, to controversy and criticism. Although the authors modified the text in response to some of these concerns, they remained adamant that the theory itself had merit. Self-control theory has been significantly supported through research, and it continues to receive attention from criminologists even today.

In sum, *A General Theory of Crime* is a well-written, accessible

academic text that will likely motivate readers to want to learn more about criminological theory, as well as inspire researchers in other academic disciplines.

SECTION 1
INFLUENCES

THE AUTHOR AND THE HISTORICAL CONTEXT

KEY POINTS

- Since its publication in 1990, *A General Theory of Crime* has significantly influenced theory and research in the field of criminology:* the study of why and how crimes are committed.

- Gottfredson and Hirschi began regular collaboration after meeting at the State University of New York at Albany.

- *A General Theory of Crime* was written in response to Gottfredson and Hirschi's dissatisfaction with the influence of positivism*—in the field of criminology, "positivism" refers to the idea that a person's behavior is shaped by his or her environment.

Why Read This Text?

Michael R. Gottfredson and Travis Hirschi's *A General Theory of Crime* proposed a new theory of crime, self-control theory,* that (they say) can be used to "explain all crime, at all times, and for that matter many forms of behavior not sanctioned by the state."[1] To support their argument, Gottfredson and Hirschi discuss the history of research in criminology and explain how different theories have led to different approaches to research in the field.

They also argue that positivism, the dominant theoretical perspective of the day, had led the field astray. Generally speaking, positivism is the philosophy that the world can be objectively or scientifically observed and described. In criminology, positivism suggests that various environmental factors determine whether

> ❝ Few topics seem more important than the bases of social and political order, more interesting than the question of human nature, or more practical than the understanding of theft and violence. ❞
>
> Michael R. Gottfredson and Travis Hirschi, *A General Theory of Crime*

someone is a criminal; a positivist theorist might assert, for example, that social class predicts if somebody might commit a crime. Gottfredson and Hirschi argued, however, that this perspective did not explain most of the existing data.[2]

The search for an alternative theory prompted them to formulate the self-control theory of crime they propose in the book. Their new theory, they argue, reconciled differences between the principles of positivism and those of more traditional perspectives on crime and human nature. *A General Theory of Crime* was (and continues to be) incredibly influential in criminology; today it has been cited nearly 3000 times.[3]

Authors' Lives

Michael R. Gottfredson (born 1951) received his BA from the University of California, Davis in 1973, and his MA and PhD from the State University of New York at Albany in 1974 and 1976, where he specialized in criminology. He went on to teach at Claremont Graduate School at the University of Illinois at Urbana and the State University of New York at Albany. In 1985, Gottfredson joined the faculty of the University of Arizona, where he would also serve as the vice president for Undergraduate Education and interim senior vice president for academic affairs and provost. From 2000 to 2012, Gottfredson served as the executive vice chancellor and provost at the University of California, Irvine. From 2012 to 2014, he was president of the University of Oregon, and he is currently a professor of

criminology, law, and society at the University of California, Irvine.[4]

Travis Hirschi (born 1935) received his BA and MA from the University of Utah in 1957 and 1958, and then earned a PhD from the University of California, Berkeley in 1968. Before the publication of *A General Theory of Crime,* Hirschi was best known for work he had done as a graduate student. His dissertation was published as the book *Causes of Delinquency* (1969). This book introduced social control (or social bonding) theory,* which asserted that weak interpersonal relationships encouraged young people to associate with delinquent* peers—peers of their age who tended to commit crimes—and ultimately to become delinquents themselves.[5]

Hirschi served on the faculty of the University of Washington and the State University of New York at Albany before taking a position at the University of Arizona, where he still works. Today, he is currently listed as an emeritus professor of sociology.[6]

Authors' Background

After receiving his bachelor's degree, Travis Hirschi was drafted into the US Army, where he spent two years as a data analyst. On his return to civilian life, Hirschi began his graduate studies at the University of California at Berkeley, where he encountered intense student activism and large-scale, influential protests, which came to be known as the free speech movement.[7]

The protests on the Berkeley campus during the 1960s and 1970s were a response to growing social unrest and political upheaval over race relations, US involvement in the Vietnam War,* and a "generational imbalance in the United States that the country had never really experienced before" in which the younger generation was "struggling to gain independence," while older generations tried "to reestablish the 1950s level of social order."[8] Crime was also significantly on the rise, and many blamed "an overly lenient criminal justice system" for this increase.[9]

It is easy to imagine that Hirschi's perspective was shaped by these events. At the very least, they formed the cultural context during his early years at the State University of New York at Albany, which he joined in 1971.

At that time, Gottfredson was a graduate student working with the American criminologist Michael Hindelang.* During this time, Hirschi, Gottfredson, and Hindelang collaborated on a number of projects that investigated the relationship between age and crime. By 1982, Hindelang's health prevented him from staying involved, but Hirschi and Gottfredson continued to work together even after Hirschi left Albany for the University of Arizona.[10]

NOTES

1 Michael R. Gottfredson and Travis Hirschi, *A General Theory of Crime* (Stanford, CA: Stanford University Press, 1990), 117.

2 Gottfredson and Hirschi, *A General Theory of Crime,* xv.

3 Social Science Citation Index, accessed October 9, 2015, http://apps. webofknowledge.com.

4 "Michael R. Gottfredson," University of California Irvine Faculty Profile System, accessed December 14, 2015, http://www.faculty.uci.edu/profile. cfm?faculty_id=4717.

5 Travis Hirschi, *Causes of Delinquency* (Berkeley: University of California Press, 1969).

6 Trina Hope, "Travis Hirschi," Oxford Bibliographies, accessed November 16, 2015, http://www.oxfordbibliographies.com/view/document/obo-9780195396607/obo-9780195396607-0107.xml.

7 Hope, "Travis Hirschi."

8 Travis C. Pratt, Travis W. Franklin, and Jacinta M.Gau, "Key Idea: Hirschi's Social Bond/Social Control Theory," in *Key Ideas in Criminology and Criminal Justice* (Thousand Oaks, CA: Sage Publications, Inc, 2011), 55–69.

9 Pratt, Franklin, and Gau, "Key Idea: Hirschi's Social Bond/Social Control Theory," 57.

10 Christopher J. Schreck, "Hirschi, Travis," in *The Encyclopedia of Theoretical Criminology* (New York: John Wiley & Sons, 2014).

MODULE 2
ACADEMIC CONTEXT

KEY POINTS

- *A General Theory of Crime* introduced a theory of crime that the authors said was better than those offered by the dominant perspective at the time, positivism* — according to which we must look to the social environment to explain why people commit crimes.

- Gottfredson and Hirschi's self-control theory* challenged a number of contemporary assumptions about, and approaches to, researching crime.

- Gottfredson and Hirschi are well-respected researchers and theorists within criminology,* the scientific study of crime and the factors that lead to and predict crime.

The Work in its Context

Michael R. Gottfredson and Travis Hirschi's *A General Theory of Crime* was a significant contribution to criminological theory.

In general, theories of crime fall into one of two major schools of thought: classicism* and positivism.[2] According to the classicist view of crime, human behavior stems from the pursuit of pleasure and the desire to avoid pain; this applies to crime and to a range of other human actions.

Crime has come to be defined as a behavior that violates the law. From the classicist perspective, crime can be controlled through assigning painful consequences to certain behaviors: criminals can be subject to physical pain, or to political, moral, or religious punishments.[3]

The positivist view of crime emphasizes factors outside of the criminal. It tries to determine what factors distinguish those who

> **❝** This book ... attempts to construct a definition of crime consistent with the phenomenon itself and with the best available theory of criminal behavior. **❞**
>
> Michael R. Gottfredson and Travis Hirschi, *A General Theory of Crime*

commit crime from those who do not. In the twentieth century, this perspective was popular in various disciplines—including biology, economics, psychology, and sociology. Each discipline explored why people became criminals through the perspective of the field's particular methods, concerns, and assumptions.

Gottfredson and Hirschi were particularly resistant to positivism because, they argued, since it is not guided by any theory of human behavior it does not account for the role of human nature and human motivation in crime.[4]

Overview of the Field

As positivism became more popular, criminology became an interdisciplinary* area of research, drawing on the aims and methods of different fields of inquiry. Biologists, psychologists, and sociologists have all contributed to what we know about crime—but this range of research interests also caused some confusion. As Gottfredson and Hirschi observed, proponents of each discipline placed the greatest worth on findings considered important to its researchers, and as a result, the understanding of crime was broken down into countless subcategories, many of which were redundant. In the authors' words, positivism results in "endless distinctions among behavioral categories and ... generates apparent interest in the countless permutations and combinations of units and their properties."[5]

Gottfredson and Hirschi were also troubled by the research methods that were being used to study crime. Specifically, they argued

that longitudinal research*—or research that tracks people over a long span of time—required too much time and money. They also asserted that longitudinal research had no clear advantage over existing rich cross-sectional* studies, in which data is collected from people who represent a range of demographic categories.[6]

While Gottfredson and Hirschi did not accept the classicist perspective entirely, they did feel that it was better than positivism. Although their self-control theory was similar to the classicist view in that it was based on the human tendency to pursue pleasure and avoid pain, it took from the positivist tradition the idea that criminals and noncriminals had different characteristics—in particular, their degree of self-control.

Academic Influences

Gottfredson and Hirschi were deeply influenced by the works of three seventeenth- and eighteenth-century philosophers: the Italian philosopher and criminologist Cesare Beccaria,* the British philosopher Jeremy Bentham,* and British social philosopher Thomas Hobbes.* Beccaria is best known for his work, *On Crimes and Punishment*. Bentham is considered the founder of the philosophy of utilitarianism*—the idea that the correct action is the one that causes the most overall good. Hobbes made important contributions to social contract theory*—the idea that people give up some individual rights to gain the benefit of living in civil society.

Beccaria, Bentham, and Hobbes laid the foundation of the classicist view of crime. They shaped Gottfredson and Hirschi's view of human nature and behavior, and encouraged them to see that the reasons that people might want to commit crimes "are ever-present possibilities in human affairs."[7]

Hobbes, in particular, remarked that crime resulted from "some defect of the understanding; or some error in the reasoning; or some sudden force of the passions."[8] The classicist view suggests that crime is

likely to occur when the possibility of pleasure outweighs the possibility of painful consequences.

This view of crime appealed to Gottfredson and Hirschi because of its simplicity, and because it seemed to be able to explain all crimes from robbery to rape to murder. It also allowed them to return to the basic principles of criminology, and to move away from the positivist theories that they found unsatisfactory.

That said, Gottfredson and Hirschi do not completely align themselves with the classicist view. According to the classicist perspective, crime could be prevented if punishments were severe enough—a principle based on the assumption that all are equally sensitive to punishments; for Gottfredson and Hirschi, however, crime occurs not simply because people are willing to risk punishment to gain pleasure, but because they lack self-control. Their theory draws on positivism, then, to the extent that it emphasizes characteristics that distinguish criminals from noncriminals.[9]

NOTES

1 Tim Newburn, *Criminology* (Cullompton: Willan, 2007), 5.

2 Michael R. Gottfredson and Travis Hirschi, *A General Theory of Crime* (Stanford, CA: Stanford University Press, 1990), xiv.

3 Gottfredson and Hirschi, *A General Theory of Crime,* 5.

4 Gottfredson and Hirschi, *A General Theory of Crime*, 47–84.

5 Gottfredson and Hirschi, *A General Theory of Crime*, 82.

6 Gottfredson and Hirschi, *A General Theory of Crime,* 217–54.

7 Gottfredson and Hirschi, *A General Theory of Crime*, 4.

8 Thomas Hobbes and J. C. A. Gaskin, *Leviathan,* Oxford World's Classics (Oxford: Oxford University Press, 1996).

9 Gottfredson and Hirschi, *A General Theory of Crime*, 11–14.

THE PROBLEM

KEY POINTS

- Contemporary criminologists* were more concerned with how the environment in which a person lives might cause him or her to commit a crime than with the idea that crime is a product of individual choice.

- According to the classicist* approach to criminology, crime was caused by human nature; for positivists,* the social environment was a key factor in deciding criminal behavior.

- Gottfredson and Hirschi shifted the debate by first focusing on defining crime itself.

Core Question

In *A General Theory of Crime*, Michael Gottfredson and Travis Hirschi wanted to develop a description of crime that would both push criminology theory forward and influence policy decisions. To do this, they first defined crime and described what conditions were necessary for it to occur. They also wanted to understand specifically the relationship between illegal force or fraudulent behavior and the pursuit of pleasure. Finally, they considered what, if any, distinctions might be made between various types of crime.[1]

It might not seem innovative that *A General Theory of Crime* begins by asking what crime is, but Gottfredson and Hirschi point out that criminologists had been focusing so much on what caused crime that they had neglected this fundamental question. Many of the theories popular at the time explored causes of crime that were external to the person who commits it.

These theories reflected the range of academic disciplines involved

> **❝** Criminology once had an idea of crime, an idea it lost with the development of the scientific perspective. **❞**
>
> Michael R. Gottfredson and Travis Hirschi, *A General Theory of Crime*

in criminological research, and the factors they claimed were most important depended on their perspective: biologists might study genes, psychologists identified personality traits, and sociologists examined social status and the environment in which a person was raised.

Additionally, some criminologists suggested that different types of crimes required different types of explanations. For instance, the well-known American criminologist Gilbert Geis* spent much of his career investigating white-collar crime*—crime that is financially motivated and nonviolent, and which is often committed by businesspeople and state officials—which he and other researchers have suggested is unique.[2] Similarly, criminologists have tried to distinguish property crimes, crimes of personal violence, and so on, as having their own, specific characteristics.

Gottfredson and Hirschi's self-control theory*—according to which all crime can be explained on the basis of how much self-control a person has—moved away from classifications and distinctions.

The Participants

Gottfredson and Hirschi believed positivism was a misguided approach to crime and criminality. While the majority of criminologists of the time were focused on what caused crime, Gottfredson and Hirschi studied the nature of crime itself.

The two were unhappy with the way that criminology researchers tended to focus only on the factors important to their disciplinary

training;[3] biologists, for example, studied genes and physiology; psychologists focused on how learning and personality factors explained crime; and sociologists analyzed, among other things, societal expectations. These ideas were not always consistent with each other, or with data that had been gathered on crime.[4] While early work in biology suggested that criminals were less evolved than non-criminals, for example, sociologists suggested the opposite: that crime was a behavior that people learned from their peers.

Another consequence of this classifying and lack of communication was that crime came to be seen as a unique behavior pattern that was somehow distinct from other types of risky or reckless behavior.[5] Criminologists such as Gilbert Geis, for example, even wrote that different types of crimes required different explanations.

Gottfredson and Hirschi's decision to focus on the nature of crime itself was a response to this context. They believed that criminology would benefit from a return to the classicist view of human nature and crime. While this was not a new idea, it did challenge the theories and methods most popular at the time.

The Contemporary Debate

At the time it was published, *A General Theory of Crime* questioned influential theoretical perspectives in use, and criticized the various disciplines that studied crime but had been unable to come up with a coherent theory about it. According to Gottfredson and Hirschi, "the strategies and premises of positivism [limited] the conception of crime and the criminal in all disciplines,"[6] and furthermore, that this interdisciplinary approach led to "petty jealousies and territorial disputes that restrict the growth and sharing of knowledge."[7]

One thing that all the disciplines did agree upon was that criminals are "compelled to commit deviant or criminal acts by forces over which they have no control."[8] Gottfredson and Hirschi disagreed with this assumption. They argued that people do exercise some degree of

choice when they decide to commit a crime, and that positivist theories did not account for the individual's decisions.

It should be noted that the authors' perspective was not unique; in the field of economics, "rational choice theory"* suggests that a person might make a decision (such as to commit a crime) if he or she determines that the benefits might outweigh the costs. While Gottfredson and Hirschi do not mention this theory in the book, Hirschi had acknowledged some overlap between the self-control theory and rational choice theory in an earlier work.[9]

NOTES

1 Michael R. Gottfredson and Travis Hirschi, *A General Theory of Crime* (Stanford, CA: Stanford University Press, 1990), 16.

2 Michael L. Benson and Elizabeth Moore, "Are White-Collar and Common Offenders the Same? An Empirical and Theoretical Critique of a Recently Proposed General Theory of Crime," *Journal of Research in Crime and Delinquency* 29, no. 3 (1992): 251–72.

3 Gottfredson and Hirschi, *A General Theory of Crime*, 15.

4 Gottfredson and Hirschi, *A General Theory of Crime,* 47–84.

5 Gottfredson and Hirschi, *A General Theory of Crime*, 10.

6 Gottfredson and Hirschi, *A General Theory of Crime*, 64.

7 Gottfredson and Hirschi, *A General Theory of Crime,* 83.

8 Gottfredson and Hirschi, *A General Theory of Crime,* 11.

9 Travis Hirschi, "On the Compatibility of Rational Choice and Social Control Theories of Crime," in *The Reasoning Criminal: Rational Choice Perspectives on Offending,* eds. Derek B. Cornish and Ronald V. Clarke, 105–18 (New York: Springer Publishing, 1986).

THE AUTHOR'S CONTRIBUTION

KEY POINTS

- Gottfredson and Hirschi wanted to develop a theory that explained all types of crime, and took into account how both environmental and personal factors encouraged or discouraged it.

- The self-control theory* of crime returned to classicist* principles of human nature—that crime is a matter of will and can be discouraged by punishment—which had fallen out of favor among contemporary criminologists.*

- The self-control theory of crime was influenced by Hirschi's early work and has clear connections with the work of other contemporary theorists.

Author's Aims

Michael R. Gottfredson and Travis Hirschi's primary aim in writing *A General Theory of Crime* was to develop a theory that explained all types of crime. They begin by focusing on the nature of crime itself. To do this, they borrow heavily from classicist views that suggest that crime, like any behavior, is guided by the pursuit of pleasure and the desire to avoid pain. According to this logic, classicists believe that crime can be controlled through a system of punishments that make it seem less worthwhile to commit a crime.[1]

As much as the authors preferred the classicist approach, they could not deny that, as positivist* theorists asserted, certain types of people seem more prone to breaking the law than others. As such, they needed their theory to account for how both human nature and the environment shaped people's behaviors. Ultimately, they conclude that

> ❝ We have for some time been unhappy with the ability of academic criminology to provide believable explanations of criminal behavior. ❞
>
> Michael R. Gottfredson and Travis Hirschi, *A General Theory of Crime*

self-control determines whether an individual will commit a crime.[2]

In proposing self-control theory, Gottfredson and Hirschi also satisfied several other interests. First, as a universal way to explain crime, self-control theory was not bound to any specific disciplinary perspective. Second, they argued, their approach would reinform the ways in which criminological research was conducted. Finally, the authors asserted that their self-control theory could lead to soundly reasoned recommendations for public policy.[3]

Approach

Gottfredson and Hirsch's approach was highly significant for its time. Their decisions to take a classicist perspective and to criticize contemporary research methods—which were time-consuming and expensive—went against then common practices in criminology.[4]

One particular aspect of positivism that Gottfredson and Hirschi took exception to was the idea of a "born criminal" who was helpless to combat his or her own biology or socioeconomic status. The nineteenth-century Italian physician Cesare Lombroso,* who worked in the penal system, proposed that criminals were "throwbacks to an earlier stage of evolution," for example, and sought to find distinguishing features common to those who broke the law.[5] Certain criminologists in economics, psychology, and sociology took a similar approach during Gottfredson and Hirschi's era.[6]

Gottfredson and Hirschi, however, concluded that aside from how much self-control a person had, there were few, if any, characteristics

that distinguished criminals from noncriminals. Rather, they saw criminal acts as similar to other kinds of human behavior, some of which were perfectly legal—smoking cigarettes or drinking alcohol, for example. The ability to exercise self-control was what determined whether, or to what extent, any particular behavior occurred.[7]

Contribution in Context

While neither Gottfredson nor Hirschi had done any work on the self-control theory of crime prior to the publication of *A General Theory of Crime*, Hirschi had published *Causes of Delinquency* in 1969 in which he outlined his social control theory.* Without strong social bonds, such as those enjoyed between members of a family, a person is more likely to become delinquent,* that is, commit crimes.

Gottfredson and Hirschi's self-control theory of crime was certainly informed by Hirschi's earlier work, though they do not make this connection explicit in *A General Theory of Crime*. It was not until later that Hirschi published a paper that merged social control and self-control theories.[8]

One critique of *A General Theory of Crime* was that the authors seem to imply that the self-control theory of crime was distinct from other theories. Yet, the thinkers the authors cited—the Italian criminologist Cesare Beccaria,* the English philosopher Jeremy Bentham,* and the English philosopher Thomas Hobbes*—had made similar arguments that, roughly, behavior is motivated by the desire to experience pleasure and to avoid pain.

Another example of a similar theory comes from the field of economics: rational choice theory,* according to which a person might make a decision if the benefits appear to outweigh the costs. American criminologist Ronald Akers* also observes that self-control theory is similar to another criminologist's claim that "'control' in all of its manifestations is the best candidate for a central and unifying 'notion' for all of sociology."[9]

NOTES

1 Michael R. Gottfredson and Travis Hirschi, *A General Theory of Crime* (Stanford, CA: Stanford University Press, 1990), 3–14.

2 Gottfredson and Hirschi, *A General Theory of Crime,* 85–120.

3 Gottfredson and Hirschi, *A General Theory of Crime*, xiii–xvi.

4 Gottfredson and Hirschi, *A General Theory of Crime*, xiv.

5 Gottfredson and Hirschi, *A General Theory of Crime,* 48.

6 Gottfredson and Hirschi. *A General Theory of Crime,* 64–84.

7 Gottfredson and Hirschi. *A General Theory of Crime,* 91.

8 Travis Hirschi, "Self-Control and Crime," in *Handbook of Self-regulation: Research, Theory, and Applications*, eds. Kathleen D. Vohs and Roy F. Baumeister, 537–52 (New York: Guilford Press, 2004).

9 Ronald L. Akers, "Self-Control as a General Theory of Crime," *Journal of Quantitative Criminology 7,* no. 2 (1991): 201–11.

SECTION 2
IDEAS

MAIN IDEAS

KEY POINTS

- *A General Theory of Crime* is organized around four major themes: crime, criminality, the application of self-control theory,* and recommendations for future research and policy.

- Gottfredson and Hirschi's main point is that an individual's degree of self-control will determine how likely they are to commit a crime.

- Gottfredson and Hirschi present both the classicist* view of human nature and the positivist* view of criminality, and they describe how self-control theory draws from each—though more from the former.

Key Themes

In *A General Theory of Crime*, Michael R. Gottfredson and Travis Hirschi introduce their self-control theory of crime. Self-control theory draws on the classicist* view of human behavior: that people seek pleasure and try to avoid pain. As such, Gottfredson and Hirschi see everyone as a potential criminal, and they assert that committing a crime has to do with how much a person can exercise self-control. That is, people with higher levels of self-control are less likely to commit a crime.

Gottfredson and Hirschi argue that people with low self-control "tend to be impulsive, insensitive, physical (as opposed to mental), risk-taking, short-sighted and nonverbal."[1] These characteristics, the authors argue, make it more likely that a person will do things that are risky and sometimes illegal.

The authors write that self-control arises relatively early in life and

> ❝ A major characteristic of people with low self-control is therefore a tendency to respond to tangible stimuli in the immediate environment, to have a concrete 'here and now' orientation. ❞
>
> Michael R. Gottfredson and Travis Hirschi, *A General Theory of Crime*

is drastically affected by a child's relationship with his or her parents. They also claim that, once established, self-control remains a stable characteristic of an individual.

A General Theory of Crime is broken into four main sections:

- The classicist perspective and the nature of crime.
- The positivist perspective and the concept of criminality.
- How self-control theory can be applied.
- Implications for future research and policies.[2]

Exploring the Ideas

Gottfredson and Hirschi argue that crime, like all behavior, is guided by the individual's desire to experience pleasure and to avoid pain. This classicist perspective suggests that crime is not some unique pattern of behavior, but is simply a small part of all human behavior—the part that the state has declared illegal.

To illustrate this, Gottfredson and Hirschi point out that people with lower levels of self-control would also be more likely to gamble and drink, even though neither of those is a crime. As they put it, people with low self-control might just as likely engage in "many noncriminal acts analogous to crime, such as accidents, smoking, and alcohol use."[3]

This view was not consistent with the positivist ideas of criminality that were dominant in criminology* at the time. Positivism presumed

that people's environments determined whether they would break the law. Gottfredson and Hirschi drew on positivism to inform their theory—but only to an extent. Their concept of self-control as a stable personal characteristic is a way of distinguishing people who are more likely to break the law from others.

Gottfredson and Hirschi are, however, generally critical of positivism, and their views diverge sharply from its principles. One such divergence is that they assume that self-control is learned early in life and is the only factor that determines whether a person will commit a crime. Another is that the authors focus on defining crime itself—the use of force or fraud to pursue one's self-interest—as opposed to the conditions that lead to crime happening.

Ultimately, self-control theory represents a compromise between the classicist and positivist perspectives. As the authors put it, self-control theory "incorporates a classical view of the role of choice and a positivistic view of the role of causation in the explanation of behavior."[4]

Having defined crime, Gottfredson and Hirschi turn their attention to showing how self-control theory accurately reflects the available data. They "review the evidence about age, gender, and race … and show how crime and self-control perspective is useful in interpreting … differences in crime rate."[5] They conclude that self-control better explains these data than any other factor.[6]

The authors then use their theory to argue against contemporary ideas about specific types of criminal behavior, such as white-collar crime*—financially motivated, nonviolent crimes usually committed by businesspeople or government officials; gang-related behavior*—crimes committed by members of a gang; and organized crime*—enterprises based on committing crimes for profit.[7]

In the final chapters, Gottfredson and Hirschi discuss the implications of their work for future criminological research and recommend policies. They dismiss the contemporary emphasis on

longitudinal research,* studies that follow individuals over some period of time. These, they argue, were costly and not justified, given that age did not seem a good predictor of crime. Furthermore, cross-sectional research,* in which researchers collect data from across demographics at one time point, was cheaper and more consistent.[8]

As for policy, Gottfredson and Hirschi suggest that the self-control theory of crime "provides a coherent base from which to judge and design public policy on crime."[9] Based on their theory's implications, they argued that teenagers should be restricted in what they were allowed to do. They also argued for funding to create early education and childcare programs that helped children develop self-control.

Language and Expression

The language that Gottfredson and Hirschi use is simple, concise, and clear. They largely avoid the use of discipline-specific jargon, and when they do use technical terms or describe complicated statistical reasoning, they provide clear, logical explanations. Most readers would find the text accessible.

The book is organized into four sections. In the first two, Gottfredson and Hirschi present important background information about the two major theoretical perspectives, classicism and positivism, that have influenced the field of criminology over time. This helps readers understand why and how they developed their self-control theory.

The next section both shows how the theory explains the existing data on crime and comments on some contemporary perspectives, discussing the unique nature of white-collar crime, as well as the time and resources required to fight organized crime when compared to other types of crime.

Finally, the text makes recommendations for future research designs, and for policy decisions that governing organizations should make.

NOTES

1 Michael R. Gottfredson and Travis Hirschi, *A General Theory of Crime* (Stanford, CA: Stanford University Press, 1990), 90.

2 Gottfredson and Hirschi, *A General Theory of Crime,* xiii–xvi.

3 Gottfredson and Hirschi, *A General Theory of Crime,* 91.

4 Gottfredson and Hirschi, *A General Theory of Crime,* 120.

5 Gottfredson and Hirschi, *A General Theory of Crime,* 124.

6 Gottfredson and Hirschi, *A General Theory of Crime,* 123–53.

7 Gottfredson and Hirschi, *A General Theory of Crime,* 154–214.

8 Gottfredson and Hirschi, *A General Theory of Crime,* 221–54

9 Gottfredson and Hirschi, *A General Theory of Crime*, 274

SECONDARY IDEAS

KEY POINTS

- Several secondary ideas are important for understanding *A General Theory of Crime*: the definition of crime as self-interested pursuit through force or fraud; the belief that theories rooted in positivism* do not adequately explain crime; and the suggestion that there is no significant relationship between crime and age, race, or gender.

- These ideas are an integral part of how the self-control theory* of crime was developed.

- Of these ideas, the most significant has been the critique of positivism, which was influential in criminology* when the book was published.

Other Ideas

In *A General Theory of Crime*, Michael R. Gottfredson and Travis Hirschi present a number of secondary ideas to better illustrate and support their self-control theory. These secondary ideas include the definition of crime as using force or fraud to pursue self-interest, a critique of positivism as an inadequate explanation for crime, and observation that age, race, and gender are not good predictors of who commits crimes.

Gottfredson and Hirschi's definition of crime reflects their classicist* view of human nature. Returning to classicist principles set the authors apart from most other contemporary criminologists of the time, who drew on positivist principles based on looking at environmental factors. Gottfredson and Hirschi thought that positivism did not adequately describe the true nature of crime.

> **66** The idea that criminal acts are an expression of fundamental human tendencies has straightforward and profound implications. **99**
>
> Michael R. Gottfredson and Travis Hirschi, *A General Theory of Crime*

Finally, the authors dedicate a substantial part of the book to discussing how factors such as age, race, and gender are not good predictors of who will commit crime. They use this idea to argue against longitudinal research* designs—studies that follow people over a long period of time.

Exploring the Ideas

In keeping with the classicist approach to criminology, Gottfredson and Hirschi argue that crime is simply an extension of the fundamental tendency of people to pursue pleasure and avoid pain. As such, they do not think it is necessary to separate crime from other types of risk-taking behaviors. In fact, they lament that criminologists pay "virtually no attention … to the general qualities of crime, to their connection with analogous noncriminal acts, or to the qualities of the targets involved in them."[1]

A significant portion of *A General Theory of Crime* is devoted to the argument that positivistic theories do not explain crime or criminal behavior adequately. For example, positivist theories are inconsistent with existing data on crime. Furthermore, the positivistic approach led to divisions among criminologists, each focused only on the characteristics of criminals that were relevant to their discipline (commonly biology, economics, psychology, and sociology).

Criminologists have long known certain factors, such as age, race, and gender are associated with crime. For instance, crime tends to peak during adolescence and declines thereafter, meaning that the age

distribution of criminals stays consistent.[2] If a factor such as age does not vary, Gottfredson and Hirschi argue, than it is not important to focus on age in trying to understand crime. They made similar arguments for race and gender.[3] They also used this reasoning to inform their arguments against longitudinal research designs in criminology.

Overlooked

Considerable research investigates the accuracy of self-control theory. In the years following its publication, *A General Theory of Crime* was one of the most cited texts in both criminology and criminal justice.[4] This research has generally been supportive of the theory and its main principles.[5]

Because of this intense degree of scrutiny, few of the book's arguments have been overlooked. Less is known, however, about whether the book's policy recommendations are reasonable or practical.[6]

There have been various suggestions about how the ideas could be "revised, reconceptualized, and/or expanded."[7] The American criminologists Travis Pratt* and Francis Cullen* published a meta-analysis* that combined a number of research studies of Gottfredson and Hirschi's self-control theory that demonstrated considerable support for the importance of self-control in explaining crime. Pratt and Cullen also point out, however, that "the effect of low self-control is weaker in longitudinal studies, and variables from social learning theory* still receive support in studies that include a measure of low self-control."[8] In other words, while self-control is important, according to the meta-analysis, it is only one factor among many.

One other aspect of the book still in need of development is the idea that self-control is developed according to the ways in which a child is disciplined by his or her parents. In a follow-up paper, Hirschi further explained what kinds of disciplinary styles encourage high

levels of self-control.[9] It is worth noting, however, that other research suggests self-control might also be formed by factors other than parenting.[10]

NOTES

1 Michael R. Gottfredson and Travis Hirschi, *A General Theory of Crime* (Stanford, CA: Stanford University Press, 1990), 14.

2 Alex R. Piquero, David P. Farrington, and Alfred Blumstein, "The Criminal Career Paradigm," *Crime and Justice,* 30 (2003): 359–506.

3 Gottfredson and Hirschi, *A General Theory of Crime,* 123–53.

4 Ellen G. Cohn and David P. Farrington, "Changes in the Most-cited Scholars in Twenty Criminology and Criminal Justice Journals between 1990 and 1995," *Journal of Criminal Justice* 27, no. 4 (1999): 345–59.

5 Hasan Buker, "Formation of Self-Control: Gottfredson and Hirschi's General Theory of Crime and Beyond," *Aggression and Violent Behavior* 16, no. 3 (2011): 265–76.

6 Alex R. Piquero, "A General Theory of Crime and Public Policy," in *Criminology and Public Policy,* eds. Hugh D. Barlow and Scott H. Decker, 66–83 (Philadelphia: Temple University Press, 2010).

7 Buker, "Formation of Self-Control," 266.

8 Travis C. Pratt and Francis T. Cullen, "The Empirical Status of Gottfredson and Hirschi's General Theory of Crime: A Meta-analysis," *Criminology* 38, no. 3 (2000): 931–64.

9 Travis Hirschi, "Self-Control and Crime," in *Handbook of Self-regulation: Research, Theory, and Applications,* eds. Kathleen D. Vohs and Roy F. Baumeister, 537–52 (New York: Guilford Press, 2004).

10 Buker, "Formation of Self-Control," 266.

ACHIEVEMENT

KEY POINTS

- Gottfredson and Hirschi's self-control theory* of crime has become very influential in criminology.*

- Gottfredson and Hirschi were able to carefully analyze the existing literature and thoroughly understand the concepts central to the classicist* school of thought, which laid the foundation for their work.

- One reason that self-control theory has not been universally adopted is because Gottfredson and Hirschi claim—controversially—that self-control is the only factor necessary to explain crime, and that it remains stable after forming early in life.

Assessing the Argument

Michael R. Gottfredson and Travis Hirschi argue in *A General Theory of Crime* that self-control theory is able to explain all forms of crime in all contexts and makes more sense than theories rooted in positivism.* They say that self-control theory is a direct response to "the failings of the theories of positivistic disciplines"[1] and demonstrate thoroughly that self-control theory is consistent with the existing data. For them, it is unnecessary to focus on the environmental factors that lead to crime. Furthermore, Gottfredson and Hirschi show that various demographic variables—age, race, and gender, for example—do not vary according to time or place. These factors, in other words, do not provide much insight into crime.

To better see how this is important, consider age. While the data shows that younger people tend to break the law more often than

> ❝ This is an important book that already has begun to have a major impact on theoretical and methodological discourse in criminology. ❞
>
> Ronald L. Akers, "Self-Control as a General Theory of Crime"

more mature people, it does not tell us why one young person might commit a crime but another does not. Therefore, the authors argue against the expensive and time-consuming research approaches that were in use. Other options, they say, are more economical and equally informative. As they put it, "the present emphasis of longitudinal research leads us to overlook more promising avenues."[2]

Since the text's publication, many researchers have tested various aspects of self-control theory and have generally concluded it is accurate.[3] As a result, criminologists have returned to classicist principles that the authors felt had been largely ignored throughout the twentieth century. This has also provided criminologists with an opportunity to avoid the pitfalls of positivism—namely that researchers only focus on those subjects familiar to their specialties.

Finally, the authors say that self-control theory might lead to meaningful public policy recommendations. They wanted their work to prompt real change in how policymakers address crime as well as to influence future research.[4]

Achievement in Context

The positivistic theories that dominated criminology when *A General Theory of Crime* was published led to research being conducted from a variety of disciplinary perspectives ranging from biology to sociology. Naturally, each researcher focused on only the factors relevant to his or her discipline. According to Gottfredson and Hirschi, this disciplinary-specific approach led to "theoretical and practical obscurity."[5]

A General Theory of Crime also contained a serious critique of contemporary research designs. The authors believed that there were much less expensive designs that had "survived the most rigorous scientific tests of replication, reliability, validity, and generalizability"[6]— the basic criteria for determining the soundness and applicability of scientific results.

As a consequence of these critiques, *A General Theory of Crime* received an astonishing amount of attention from the criminological community when it was published. It quickly became the second-most-cited work in the fields of criminology and criminal justice.[7] In fact, the American criminologist Ronald Akers,* an early critic of the work, suggested that "even those who will take issue with many of its assertions (I count myself among this number) must admit to the power, scope, and persuasiveness of its argument."[8]

Limitations

Gottfredson and Hirschi's *A General Theory of Crime* proved to be one of the most influential and controversial works of its time. Much of the research based on the book's arguments has suggested that self-control theory can be broadly applied. For instance, one global study examined whether the theory held true in 32 national contexts with different social and economic conditions and concluded that the authors were "impressed with strength of support for the General Theory's micro-level predictions, and perhaps more impressed with the consistency of this support in such disparate national settings."[9]

Even though self-control theory is widely recognized as valid, there is considerable disagreement about how people develop self-control, and about the degree to which factors other than self-control also play a role in crime. For instance, one scholar noted that "the cause of self-control is not limited to parental socialization processes," and that "there are several other biological (genetic, neuropsychological, etc.) and social-structural factors affecting the generation of self-

control."[10] Still other research suggests that social learning theory,*
which says that criminal behavior is learned and reinforced through
social interaction, might also help explain crime.[11]

NOTES

1 Michael R. Gottfredson and Travis Hirschi, *A General Theory of Crime*
 (Stanford, CA: Stanford University Press, 1990), 120.

2 Gottfredson and Hirschi, *A General Theory of Crime,* 252.

3 Travis C. Pratt and Francis T. Cullen, "The Empirical Status of Gottfredson
 and Hirschi's General Theory of Crime: A Meta-analysis," *Criminology* 38,
 no. 3 (2000): 931–64.

4 Gottfredson and Hirschi, *A General Theory of Crime,* 274.

5 Gottfredson and Hirschi, *A General Theory of Crime,* xiii.

6 Gottfredson and Hirschi, *A General Theory of Crime,* 254.

7 Ellen G. Cohn and David P. Farrington, "Changes in the Most-cited Scholars
 in Twenty Criminology and Criminal Justice Journals between 1990 and
 1995," *Journal of Criminal Justice* 27, no. 4 (1999): 345–59.

8 Ronald L. Akers, "Self-Control as a General Theory of Crime," *Journal of
 Quantitative Criminology* 7, no. 2 (1991): 201.

9 Cesar J. Rebellon, Murray A. Straus, and Rose Medeiros, "Self-Control in
 Global Perspective: An Empirical Assessment of Gottfredson and Hirschi's
 General Theory within and across 32 National Settings," *European Journal
 of Criminology* 5, no. 3 (2008): 331–62.

10 Hasan Buker, "Formation of Self-Control: Gottfredson and Hirschi's General
 Theory of Crime and Beyond," *Aggression and Violent Behavior* 16, no. 3
 (2011): 265–76.

11 Pratt and Cullen, "The Empirical Status of Gottfredson and Hirschi's
 General Theory of Crime."

PLACE IN THE AUTHOR'S WORK

KEY POINTS

- Michael R. Gottfredson and Travis Hirschi spent their careers researching crime and exploring how crime can be controlled.

- *A General Theory of Crime* was the culmination their research, and it was especially influenced by Hirschi's earlier work.

- *A General Theory of Crime* represents the pinnacle of Gottfredson and Hirschi's impressive careers in criminology.*

Positioning

Before he coauthored *A General Theory of Crime*, much of Michael R. Gottfredson's early work involved victimization[1] and how decisions were made in the criminal justice system.[2] Hirschi, on the other hand, had been interested in the factors that contributed to crime since his time as a graduate student at the University of California, Berkeley. His dissertation was published as the book *Causes of Delinquency* (1969).[3] In it, Hirschi proposed social control theory,* which asserted that people with weak social bonds—commonly those between members of a family or community—were more likely to associate with delinquent* peers who were likely to commit crimes, and become delinquent themselves.

This early work by Hirschi significantly shaped self-control theory.* In fact, he would later merge self-control theory and social control theory in an academic article published after the publication of *A General Theory of Crime*.[4]

> **❝ The team of Travis Hirschi and Michael Gottfredson is one of the most productive and influential collaborations in criminology. ❞**
>
> Ronald L. Akers, "Self-Control as a General Theory of Crime"

A General Theory of Crime was a significant academic achievement for both authors. In it, they address their dissatisfaction with positivism,* and their hope "to renew some intellectual interest in criminology, a field that once engaged the finest minds in the community."[5]

Integration

Gottfredson and Hirschi have always been consistent in their academic work. Hirschi, for example, has focused on the factors that lead to crime since he was a graduate student. Even before the publication of *A General Theory of Crime,* Hirschi and Gottfredson collaborated on a number of projects. These laid the groundwork for the self-control theory of crime. For instance, in 1983, they published a paper called "Age and the Explanation of Crime" that, in *A General Theory of Crime,* formed the basis of the argument against research studies that focus on age.[6]

After *A General Theory of Crime* was published, it became the second-most-cited work in criminology and criminal justice literature,[7] and it remains very influential in contemporary research. Following the book's publication, Gottfredson and Hirschi continued to collaborate to defend[8] and expand[9] their self-control theory.

They have been willing to adapt the theory in response to criticism and further research. For instance, in 2003, the two published the essay "Self-control and Opportunity," which modified self-control theory to account for the role that opportunity plays in crime.

Significance

Michael R. Gottfredson and Travis Hirschi contributed significantly to the fields of criminology and criminal justice over their careers, which has led to them holding important leadership positions at their respective institutions. Gottfredson served as president of the University of Oregon, and Hirschi as the president of the American Society for Criminology.

Hirschi has long been recognized as an important figure within criminology. One scholar described him as "one of the most influential criminologists since the 1960s."[10] Hirschi's first book *Causes of Delinquency* lays out his social control theory of delinquency, which was tremendously influential among criminologists. Just as with self-control theory, it was widely tested and researched.

Hirschi was also a significant influence on Gottfredson, who was a graduate student at the State University of New York at Albany when the two met. While some of Gottfredson's research interests did not relate to the work that he did with Hirschi, it is fair to say that their collaborations—especially *A General Theory of Crime*—represent Gottfredson's most important contributions to criminology.[11]

NOTES

1 Michael R. Gottfredson, "On the Etiology of Criminal Victimization," *Journal of Criminal Law and Criminology* 72, no. 2 (1981): 714–26.

2 Michael R. Gottfredson, "An Empirical Analysis of Pre-trial Release Decisions," *Journal of Criminal Justice* 2, no. 4 (1975): 287–304.

3 Travis Hirschi, *Causes of Delinquency* (Berkeley: University of California Press, 1969).

4 Travis Hirschi, "Self-Control and Crime," in *Handbook of Self-Regulation: Research, Theory, and Applications,* eds. Kathleen D. Vohs and Roy F. Baumeister, 537–52 (New York: Guilford Press, 2004).

5 Michael R. Gottfredson and Travis Hirschi, *A General Theory of Crime* (Stanford, CA: Stanford University Press, 1990), 275.

6 Travis Hirschi and Michael Gottfredson, "Age and the Explanation of Crime," *The American Journal of Sociology* 89, no. 3 (1983): 552–84.

7 Ellen G. Cohn and David P. Farrington, "Changes in the Most-cited Scholars in Twenty Criminology and Criminal Justice Journals between 1990 and 1995," *Journal of Criminal Justice* 27, no. 4 (1999): 345–59.

8 Travis Hirschi and Michael R. Gottfredson, "Commentary: Testing the General Theory of Crime," *Journal of Research in Crime and Delinquency* 30, no. 1 (1993): 47–54.

9 Michael R. Gottfredson and Travis Hirschi, "Self-Control and Opportunity," in *Control Theories of Crime and Delinquency,* eds. Chester L. Britt and Michael R. Gottfredson, 5–18 (New Brunswick, NJ: Transaction Publishers, 2003).

10 Christopher J. Schreck, "Hirschi, Travis," *The Encyclopedia of Theoretical Criminology* (New York: John Wiley & Sons, 2014).

11 Lyndi Thorman, "Gottfredson, Michael," *The Encyclopedia of Theoretical Criminology* (New York: John Wiley & Sons, 2014).

SECTION 3
IMPACT

MODULE 9
THE FIRST RESPONSES

KEY POINTS

- *A General Theory of Crime* was criticized as simply restating earlier arguments, being too simplistic, failing to account for other theoretical perspectives, oversimplifying white-collar crime,* and failing to account for how opportunity leads to crime.
- Gottfredson and Hirschi responded both by refuting these arguments and conceding that self-control theory* could be improved. They also published additional research that accounted for the role of opportunity in crime.
- There is some agreement among scholars that self-control does predict crime; however, it is unclear to whether or not there are other important variables.

Criticism

A General Theory of Crime has received considerable scrutiny and criticism since its publication in 1990. One of the first critiques came from the American criminologist* Ronald L. Akers,* who said that the self-control argument was tautological*—it used circular logic. Specifically, Akers argued that it was impossible to distinguish the concept of self-control from crime itself, saying the concepts of crime and low self-control "are one and the same, and such assertions about them are true by definition. The assertion means that low self-control causes low self-control."[1] His argument, then, is that the theory of self-control was based on faulty logic.

Additionally, Akers critiqued the way the book's authors, Michael R. Gottfredson and Travis Hirschi implied that their theory sharply diverged from other theories of the day. Akers pointed out that it was

> **❝ A general theory is possible neither in regard to human acts nor to so broad a category as criminal behavior. ❞**
>
> Gilbert Geis, "On the Absence of Self-Control as the Basis for a General Theory of Crime: A Critique"

actually closely linked to existing theories, such as Hirschi's own social control theory,* and to other notions of control that existed in the literature. As such, Akers argues that Gottfredson and Hirschi failed to sufficiently establish and acknowledge what they owed to previously existing theories.[2]

Akers was not the only early critic of *A General Theory of Crime*. In 1992, another pair of scholars published a study suggesting that self-control theory could not explain white-collar crime.[3] They argued that the self-control theory's "rejection of motives as important causal forces is misguided and that a more complex causal structure is needed to account for patterns of white-collar offending."[4] In other words, they determined that in the case of white-collar crime, there were other reasons than a lack of self-control that might cause people to want to break the law.

Similarly, another group of scholars argued that Gottfredson and Hirschi had not sufficiently considered the role that opportunity plays in crime. Opportunity, they said, could predict crime regardless of whether self-control was accounted for. They went on to suggest that low self-control accounts for only a small amount of crime;[5] while acknowledging that "Gottfredson and Hirschi's formulation constitutes a significant innovation," they added that "it requires additional theoretical work."[6]

Responses

Gottfredson and Hirschi have responded to some of these criticisms. To the accusation that their argument was tautological, they

responded, "the charge of tautology is in fact a compliment; an assertion that we followed the path of logic in producing an internally consistent result."[7] In other words, they simply agree that self-control and crime are quite similar, since self-control predicts crime. They disagree that this observation is actually a criticism.

Akers's suggestion that self-control theory should be more clearly linked to other theories produced more of a concession: in a paper of 2004, Hirschi merged self-control theory with his earlier social control theory, acknowledging that self-control is formed through a person's social bonds and associations. He wrote that "the two theories may be accommodated by assuming the strength-of-bond differences between individuals are in fact stable and are a major component of self-control."[8]

To those critics who argued that self-control theory does not explain white-collar crime, Gottfredson and Hirschi responded that their claims had been misunderstood. They argue that a "white collar offender should on the whole have higher levels of self-control than those" who do not. This is because people who commit so-called white-collar crimes are generally employed, and the authors argue that those who are employed also tend to have higher levels of self-control. They then note that white-collar criminals' records "show fewer offenses and 'offense types'"[9]—findings that might be expected if the theory were correct.

Finally, to address the criticisms of those who argued that they had not accounted for the role opportunity plays in crime, Gottfredson and Hirschi published a book chapter in 2003 that focused on exactly that topic. In fact, the authors suggest that "the interaction of varying individual predispositions for delinquency* and logically possible opportunities is one of the most significant and complex problems confronting modern criminology."[10] In doing so, they explore how opportunity and levels of self-control both contribute to crime.

Conflict and Consensus

A General Theory of Crime prompted a great deal of research to test the prediction self-control theory made. This isn't surprising, given how critical Gottfredson and Hirschi were of the state of criminology at the time. However, much of the research and debate that followed the book's publication has resulted in support for self-control theory. Today, while the debate about the merits and scope of the self-control theory continues, there is certainly some consensus that self-control plays an important role in predicting and explaining crime.[11]

That said, a few issues are still being studied and discussed. For example, some research has resulted in only partial support for the theory. One research group demonstrated that self-control appeared to be important, but was not enough to explain all criminal behavior.[12] Gottfredson and Hirschi dismissed this study because it used self-reporting, rather than direct observation, to measure self-control. Self-control cannot be measured through self-reporting, they argue, because people do not accurately report their own experiences.

One debate that seems to have been resolved is about how self-control theory should be linked to other criminological theories. Hirschi seems to have satisfied these concerns in his merging of self-control and social control theories.[13]

NOTES

1 Ronald L. Akers, "Self-Control as a General Theory of Crime," *Journal of Quantitative Criminology* 7, no. 2 (1991): 204.

2 Akers, "Self-Control as a General Theory of Crime."

3 Michael L. Benson and Elizabeth Moore, "Are White-Collar and Common Offenders the Same? An Empirical and Theoretical Critique of a Recently Proposed General Theory of Crime," *Journal of Research in Crime and Delinquency* 29, no. 3 (1992): 251–72.

4 Benson and Moore, "Are White-Collar and Common Offenders the Same?" 251.

5 Harold G. Grasmick et al, "Testing the Core Empirical Implications of Gottfredson and Hirschi's General Theory of Crime," *Journal of Research in Crime and Delinquency* 30, no. 1 (1993): 5–29.

6 Grasmick et al, "Testing the Core Implications," 29.

7 Travis Hirschi and Michael Gottfredson, "Commentary: Testing the General Theory of Crime," *Journal of Research in Crime and Delinquency* 30, no. 1 (1993): 47–54.

8 Travis Hirschi, "Self-Control and Crime," in *Handbook of Self-Regulation: Research, Theory, and Applications,* eds. Kathleen D. Vohs and Roy F. Baumeister (New York: Guilford Press, 2011), 537–52.

9 Hirschi and Gottfredson, "Commentary: Testing the General Theory of Crime," 54.

10 Michael R. Gottfredson and Travis Hirschi, "Self-Control and Opportunity," in *Control Theories of Crime and Delinquency,* eds. Chester L. Britt and Michael R. Gottfredson (New Brunswick, NJ: Transaction Publishers, 2003), 5–18.

11 Travis C. Pratt and Francis T. Cullen, "The Empirical Status of Gottfredson and Hirschi's General Theory of Crime: A Meta-Analysis," *Criminology* 38, no. 3 (2000): 931–64.

12 Grasmick, et al, "Testing the Core Implications."

13 Akers, "Self-Control as a General Theory of Crime."

THE EVOLVING DEBATE

KEY POINTS

- *A General Theory of Crime* sparked renewed interest in control theories* — theories that propose ways to restrain people from committing crimes.
- The book has caused significant debate and opened new lines of research in criminology.*
- While the self-control theory* of crime is supported by data, it is unclear if variables other than self-control are also important for explaining and predicting crime.

Uses and Problems

A General Theory of Crime by Michael R. Gottfredson and Travis Hirschi encouraged criminologists to return to studying the personal characteristics of criminals in order to determine who is likely to commit crimes. It also led to renewed interest in control theories of crime—inquiry into the ways in which criminal activity might be restrained.

One particularly important debate has been whether a person's self-control is the only important variable in predicting crime. Gilbert Geis,* an American criminologist who studied white-collar crime,* wrote that "researchers typically find that there is a better than average chance that persons who commit traditional kinds of criminal acts lack self-control," but that the same researchers "also find that there are many persons who do not fit the criteria … [of] low self-control who violate the law."[1]

> **❝** I presume that self-control theory in due time will join the now-crowded cohort of vainglorious efforts in whatever place is reserved for such endeavors. **❞**
>
> Gilbert Geis, "On the Absence of Self-Control as the Basis for a General Theory of Crime: A Critique"

Schools of Thought

Gottfredson and Hirschi were unhappy with the influence that theories rooted in positivism* had on criminological research. *A General Theory of Crime* encouraged criminologists to return to classicist* principles; the renewed interest in control theories came as a consequence of this return.

While self-control theory was certainly not the first control theory to be proposed, it quickly became one of the best known and influential. Additionally, because self-control theory has been so important, many other control theories have since been developed.

In one sense, this is not surprising. Hirschi had long been known as a control theorist; his social control theory,* described in his *Causes of Delinquency* (1969), was, as its name suggests, a control theory.[2] In this book, Hirschi argued that people with strong social bonds and attachments were less likely to commit crimes than those who lacked those characteristics. He would later merge this theory with self-control theory in a 2004 paper.[3]

In Current Scholarship

A quarter of a century after its initial publication, *A General Theory of Crime* has led to, in Gilbert Geis's words, "a flourishing criminological cottage industry that has seized upon self-control as a research topic."[4] Similarly, Travis Pratt,* a US criminologist who recently proposed an updated version of self-control theory, states that the importance of self-control within the criminological community is "such a 'given'

that the field has largely moved on to other areas of self-control research."[5]

The concept of self-control has become a popular research topic for today's criminologists. Some have investigated the role that parental socialization and other factors play in the formation of self-control.[6] Others are inquiring into whether self-control is, as Gottfredson and Hirschi asserted, a relatively stable personal characteristic.[7] Still other researchers are trying to find out if other characteristics are as important as self-control in predicting and explaining crime.[8]

NOTES

1 Gilbert Geis, "On the Absence of Self-Control as the Basis for a General Theory of Crime: A Critique," *Theoretical Criminology* 4, no. 1 (2000): 46.

2 Travis Hirschi, *Causes of Delinquency* (Berkeley: University of California Press, 1969).

3 Travis Hirschi, "Self-Control and Crime," in *Handbook of Self-Regulation: Research, Theory, and Applications,* eds. Kathleen D. Vohs and Roy F. Baumeister, 537–52 (New York: Guilford Press, 2004).

4 Geis, "On the Absence of Self-Control," 45.

5 Travis C. Pratt, "A Reconceptualized Model of Self-Control and Crime," *Criminal Justice and Behavior* 42, no. 6 (2015): 662–79.

6 Hasan Buker, "Formation of Self-Control: Gottfredson and Hirschi's General Theory of Crime and Beyond," *Aggression and Violent Behavior* 16, no. 3 (2011): 265–76

7 Pratt, "A Reconceptualized Model of Self-Control and Crime."

8 Travis C. Pratt and Francis T. Cullen, "The Empirical Status of Gottfredson and Hirschi's General Theory of Crime: A Meta-analysis," *Criminology* 38, no. 3 (2000): 931–64.

MODULE 11
IMPACT AND INFLUENCE TODAY

KEY POINTS

- *A General Theory of Crime* is still relevant in criminology* today.
- Criminologists continue to question and discuss the book's claims about how self-control is formed, whether it remains stable, and whether the theory truly can be used to explain all crimes.
- As important as self-control theory* has become, modern criminologists generally agree that certain aspects need to be modified or expanded.

Position

A General Theory of Crime provoked a tremendous reaction when it was published in 1990. Given how critical its authors, Michael R. Gottfredson and Travis Hirschi, were of criminological research and theory at the time, it should come as no surprise that much of this reaction was criticism. For example, Ronald L. Akers's* review of the book argued that self-control theory conflated the concepts of self-control and crime, and was therefore based on faulty logic.[1]

Although much of the research prompted by the book turned out to support its theory, some of the evidence has also suggested that self-control is more complicated than Gottfredson and Hirschi predicted.[2] Regardless, the continued research into self-control demonstrates just how relevant *A General Theory of Crime* is to the modern criminological community.

Interaction

Even though research into self-control and crime has supported Gottfredson and Hirschi's explanation for criminal behavior, it also

> **❝** Since its introduction to the criminological community
> by Gottfredson and Hirschi in 1990, empirical* research
> has demonstrated that self-control is a robust predictor
> of a wide variety of criminal offenses under an equally
> wide variety of methodological conditions. **❞**
>
> Travis C. Pratt, "A Reconceptualized Model of Self-Control and Crime"

suggests that the authors' conception of self-control's role in criminal behavior may be overly simplistic.

For example, Gottfredson and Hirschi argue that self-control is the only variable that needs to be accounted for when explaining and predicting crime. While it is true that self-control is important, research suggests it is not the only factor. After conducting a meta-analysis*— research that combines the findings of a number of independent studies on the same topic—the US criminologists Travis Pratt* and Francis Cullen* remark that "variables from social learning theory* still receive support in studies that include a measure of low self-control."[3] That is, the strength of someone's personal relationships also seem to affect whether he or she commits a crime.

Another point of contention is Gottfredson and Hirschi's assertion that parenting plays the most important role in the formation of self-control. A 2011 review of over 40 studies that focused on this topic, however, suggested that in addition to parenting, evidence that "social context, education process, [and] biological" factors also play important roles in the development of self-control.[4]

Finally, Gottfredson and Hirschi claim that the theory explains all types of crimes in all places. Once again, while research does reveal that it is broadly applicable, it is unclear that it is truly universal. Gilbert Geis,* who is considered a "seminal white-collar crime* researcher,"[5] has been one of the most vocal critics on this front; he says he can offer

"a considerable roster of proscribed [forbidden] acts … which seem to have little relationship to either the presence of absence of self-control."[6]

The Continuing Debate

Not all criticism of self-control theory is the result of research that investigates its main principles. Some is motivated by the need to defend perspectives that Gottfredson and Hirschi initially critiqued.

Gilbert Geis, for example, has dedicated his career to investigating the particular characteristics of white-collar crime. Given that Gottfredson and Hirschi argued that white-collar crime was the same as any other kind, it should come as no surprise that Geis has critiqued self-control theory. He writes that "several major reviews of self-control theory and white-collar crime have demonstrated that its application to white-collar crime, defined as it traditionally has been, shows gaping holes."[7]

Geis also appears unsatisfied with some of the responses that Gottfredson and Hirschi have made in regards to criticisms that they have faced. For example, they responded to the critique that their theory was based on circular logic—because self-control and crime seem to be the same thing—by simply agreeing, saying in effect that the critique was not actually a critique. This response seems to have left Geis incredulous; he remarks, "one can only hope that the authors allowed themselves a bit of a smile here."[8]

Clearly, then, Gottfredson and Hirschi's *A General Theory of Crime* is still relevant to discussion and debate within criminology today. The book still inspires new lines of research, and critics continue to scrutinize its ideas and study its implications.

NOTES

1 Ronald L. Akers, "Self-Control as a General Theory of Crime," *Journal of Quantitative Criminology* 7, no. 2 (1991): 201–11.

2 Travis C. Pratt, "A Reconceptualized Model of Self-Control and Crime," *Criminal Justice and Behavior* 42, no. 6 (2015): 673.

3 Travis C. Pratt and Francis T. Cullen, "The Empirical Status of Gottfredson and Hirschi's General Theory of Crime: A Meta-analysis," *Criminology* 38, no. 3 (2000): 931–64.

4 Hasan Buker, "Formation of Self-Control: Gottfredson and Hirschi's General Theory of Crime and Beyond," *Aggression and Violent Behavior* 16, no. 3 (2011): 265–76.

5 Dick Carozza, "He Sought and Brought Out the Best in Everyone: Gilbert Geis, PhD, CFE (1925–2012)," *Fraud Magazine*, March/April 2013, accessed October 20, 2015. http://www.fraud-magazine.com/article. aspx?id=4294977176.

6 Gilbert Geis, "On the Absence of Self-Control as the Basis for a General Theory of Crime: A Critique," *Theoretical Criminology* 4, no. 1 (2000): 37.

7 Geis, "On the Absence of Self-Control," 44.

8 Geis, "On the Absence of Self-Control," 39.

MODULE 12
WHERE NEXT?

KEY POINTS

- It is likely that self-control theory* will continue to influence the field of criminology* in the future.

- Criminologists will continue to explore, expand, and modify self-control theory's central claims.

- *A General Theory of Crime* is a foundational text* both for its criticism of positivism* and its criminological research methods, and for its argument that self-control can explain and predict all crimes.

Potential

Criminologists today still explore various aspects of self-control theory as introduced by Michael R. Gottfredson and Travis Hirschi in their 1990 book, *A General Theory of Crime*. For instance, one criminologist recently published a paper that found interesting differences between the levels of self-control in men and women. This is not the only finding of its type, and the authors wondered in their discussion if other factors such as "race/ethnicity would moderate any of the relationships" between measures of self-control and criminal behavior.[1]

Another researcher suggests that self-control theory be revised to account for the idea that "self-control may be situationally contingent, where one's ability to exercise self-control depends upon one's desires to do so, which can shift and change across situations."[2] In other words, self-control might vary from situation to situation. This way of thinking would be a significant shift from Gottfredson and Hirschi's

> **❝** Although certainly not without its critics, the self-control tradition has remained vibrant in criminology for over two and a half decades. **❞**
>
> Travis C. Pratt, "A Reconceptualized Model of Self-Control and Crime"

idea that self-control remains stable over the course of a person's life.

While these are only two examples of the current directions that researchers of self-control theory today are taking, they illustrate that Gottfredson and Hirschi's *A General Theory of Crime* continues to inspire research, and that its claims will be investigated for many years to come.

Future Directions

Given the great quantity of inquiry self-control theory has provoked, it is difficult to identify any single line of questioning as the most significant. That said, the work of Travis C. Pratt,* a fellow at the University of Cincinnati's Corrections Institute, is worth mentioning.

Pratt has had a prolific publishing career in criminology.[3] Most recently, he published a paper that explored Gottfredson and Hirschi's concept of self-control as a stable individual characteristic. Pratt argues that it is limiting to see self-control as stable. There is instead evidence that self-control is a variable trait, and that this variability is itself an important factor in crime.

Pratt suggests that these findings "reveal support for a reconceptualization of self-control that incorporates both static and dynamic dimensions."[4] That is, he believes that our concept of self-control must account for how it varies from situation to situation. While this contradicts Gottfredson and Hirschi's original idea, it does support the modifications that Hirschi made in his 2004 publication in which he merged social control* and self-control theories of crime.[5]

Pratt's interest in trying to improve the theory shows that he has considerable respect for it. As he puts it, "self-control theory has been consistently good, but certainly not perfect … [and it] needs to be revised to include the notion of self-control variability."[6] Pratt's work demonstrates both that self-control theory is relevant in how we understand and explain crime, and also that it can still be improved.

Summary

Gottfredson and Hirschi's *A General Theory of Crime* was among the most significant theoretical contributions to criminology. The attention the text has received makes it foundational for those seeking to understand crime. It is also important reading for anyone who wants to learn about the history and evolution of criminology, as Gottfredson and Hirschi discuss the field's origins at length in the book.

Though the book has met with substantial criticism, much of the research into self-control theory has resulted in data that supports Gottfredson and Hirschi's claims. Even today, criminologists continue to investigate just how "general" the theory of self-control is. This might be because of the theory's simple elegance in explaining how those with low levels of self-control are more likely to commit crime than those with at least normal levels, or simply because the authors were so dismissive of the dominant views at the time. Regardless, Gottfredson and Hirschi's *A General Theory of Crime* has undeniably left its mark on criminology.

NOTES

1 Jeff Bouffard, Jessica M. Craig, and Alex R. Piquero, "Comparing Attitudinal and Situational Measures of Self-Control among Felony Offenders," *Criminal Behavior and Mental Health* 25 (2015): 112–25.

2 Travis C. Pratt, "A Reconceptualized Model of Self-Control and Crime," *Criminal Justice and Behavior* 42, no. 6 (2015): 675.

3 "Fellows: Dr. Travis C. Pratt," University of Cincinnati Corrections Institute, accessed October 20, 2015, http:/www.uc.edu/corrections/contact/fellows.html.

4 Pratt, "A Reconceptualized Model," 662.

5 Travis Hirschi, "Self-Control and Crime," in *Handbook of Self-Regulation: Research, Theory, and Applications,* eds. Kathleen D. Vohs and Roy F. Baumeister, (New York: Guilford Press, 2004), 537–52.

6 Pratt, "A Reconceptualized Model," 675.

GLOSSARY

GLOSSARY OF TERMS

Classicism: a school of thought that, within criminology, emphasizes free will; as a consequence, classicism suggests that crime can be deterred through punishment.

Control theory: a theory that describes how people can be restrained or deterred from committing crimes. Self-control theory is one of several control theories.

Criminology: the study of the causes and effects of crime.

Cross-sectional research: a research method comparing people from multiple demographic categories (or characteristics such as age, gender, or location) at one point in time.

Delinquency: the tendency to commit crimes; a word commonly used for young people.

Empirical: verifiable through observation.

Foundational text: A text that makes a significant and long-standing change in theory and methodology.

Gang-related behavior: criminal acts committed as a part of membership in a gang. A gang is a group of people who work together to control territory and profit, often through illegal means.

Longitudinal research: a method of research in which the researcher follows his subjects over a period of time.

Meta-analysis: research that combines the findings of multiple independent studies on the same topic.

Organized crime: criminal enterprises that profit through crime.

Positivism: a school of thought that emphasizes scientific observation. In criminology, positivism asserts that criminal behavior is influenced by environmental factors, which at least partially determine a person's actions.

Rational choice theory: suggests that a person might make a decision (such as to commit a crime) if she or he determines that the benefits might outweigh the costs.

Social contract: The unspoken contract people make when they give up certain rights to live peaceably with others.

Self-control theory: a theory suggesting that people with low levels of self-control are more likely to commit crime than those with normal or high levels.

Social bonding/Social control theory: proposed by Hirschi in 1969, this theory suggests that criminal behavior is restrained when people have strong interpersonal relationships.

Social learning theory: a theory suggesting that criminal behavior is learned and reinforced through a person's social relationships.

Tautology: using different words to describe the same thing, using circular logic.

Vietnam War: a two-decade-long military conflict between communist forces, led by North Vietnam, and anti-communist forces, led by the United States and South Vietnam. Starting in 1955 and finishing in 1975 following the withdrawal of American troops from Vietnamese territory, this was the longest sustained conflict with direct US military involvement during the Cold War. The escalation of American involvement in the war was highly controversial and sparked nationwide antiwar protests in the US.

White-collar crime: a type of crime typically committed by businesspeople or government officials, usually for financial gain.

Utilitarianism: the philosophy that the best action is the one that does the most good for the most people.

PEOPLE MENTIONED IN THE TEXT

Ronald L. Akers (b. 1939) is an American criminologist best known for his social learning theory, currently an emeritus professor of criminology and law at the University of Florida.

Cesare Beccaria (1738–94) was an Italian philosopher and criminologist. He is best known for his text *On Crimes and Punishment* (1764).

Jeremy Bentham (1748–1832) was a British philosopher and a supporter of the philosophy of utilitarianism, which asserts that the best action is the one that does the most good for the most people.

Francis T. Cullen (b. 1951) is an American criminologist who has over 300 publications on a wide range of topics. He is currently a distinguished research professor emeritus and senior research associate at the University of Cincinnati.

Gilbert Geis (1925–2012) was an American criminologist best known for his work on white-collar crime. Dr. Geis was professor emeritus of criminology, law, and society at the University of California, Irvine.

Michael Hindelang (1946–82) was an American criminologist who collaborated with Gottfredson and Hirschi before his death in 1982. He was a professor of criminal justice at the State University of New York at Albany.

Thomas Hobbes (1588–1679) was a British philosopher best known for his role in the development of social contract theory, in

which citizens give up certain liberties in exchange for a stable and secure civil society. His best-known work is *Leviathan* (1651).

Cesare Lombroso (1835–1909) was an Italian physician and criminologist. Lombroso is sometimes referred to as the father of criminology.

Travis C. Pratt (b. 1973) is an American criminologist who recently proposed an updated version of the self-control theory of crime. Dr. Pratt is currently a fellow at the University of Cincinnati Corrections Institute.

WORKS CITED

WORKS CITED

Akers, Ronald L. "Self-Control as a General Theory of Crime." *Journal of Quantitative Criminology* 7, no. 2 (1991): 201–11.

Benson, Michael L., and Elizabeth Moore. "Are White-Collar Offenders the Same? An Empirical and Theoretical Critique of a Recently Proposed General Theory of Crime." *Journal of Research in Crime and Delinquency* 29, no. 3 (1992): 251–72.

Bouffard, Jeff, Jessica Craig, and Alex R. Piquero. "Comparing Attitudinal and Situational Measures of Self-Control among Felony Offenders." *Criminal Behavior and Mental Health* 25, no. 2 (2015): 112–25.

Buker, Hasan. "Formation of Self-Control: Gottfredson and Hirschi's General Theory of Crime and Beyond." *Aggression and Violent Behavior* 16, no. 3 (2011): 265–76.

Carozza, Dick. "He Sought and Brought Out the Best in Everyone: Gilbert Geis, PhD, CFE (1925–2012)." *Fraud Magazine,* March/April 2013. Accessed October 20, 2015. http://www.fraud-magazine.com/article.aspx?id=4294977176.

Cohn, Ellen G., and David P. Farrington. "Changes in the Most-Cited Scholars in Twenty Criminology and Criminal Justice Journals between 1990 and 1995." *Journal of Criminal Justice* 27, no. 4 (1999): 345–59.

Geis, Gilbert. "On the Absence of Self-Control as the Basis for a General Theory of Crime: A Critique." *Theoretical Criminology* 4, no. 1 (2000): 35–53.

Gottfredson, Michael R. "An Empirical Analysis of Pre-Trial Release Decisions." *Journal of Criminal Justice* 2, no. 4 (1975): 287–304.

———."On the Etiology of Criminal Victimization." *Journal of Criminal Law and Criminology* 72, no. 2 (1981): 714–26.

Gottfredson, Michael R., and Travis Hirschi. *A General Theory of Crime.* Stanford, CA: Stanford University Press, 1990.

———. "Self-Control and Opportunity." In *Control Theories of Crime and Delinquency,* edited by Chester L. Britt and Michael R. Gottfredson, 5–18. New Brunswick, NJ: Transaction Publishers, 2003.

Grasmick, Harold G., Charles R. Tittle, and Robert J. Bursick, Hr., and Bruce J. Arneklev. "Testing the Core Empirical Implications of Gottfredson and Hirschi's General Theory of Crime." *Journal of Research in Crime and Delinquency* 30, no. 1 (1993): 5–29.

Hirschi, Travis. *Causes of Delinquency.* Berkeley: University of California Press, 1969.

———. "On the Compatibility of Rational Choice and Social Control Theories of Crime." In *The Reasoning Criminal: Rational Choice Perspectives on Offending,* edited by Derek B. Cornish and Ronald V. Clarke, 105–18. New York: Springer Publishing, 1986.

———. "Self-Control and Crime." In *Handbook of Self-Regulation: Research, Theory, and Applications,* edited by Kathleen D. Vohs and Roy F. Baumeister, 537–52. New York: Guilford Press, 2004.

Hirschi, Travis, and Michael R. Gottfredson. "Commentary: Testing the General Theory of Crime." *Journal of Research in Crime and Delinquency* 30, no. 1 (1993): 47–54.

———. "Substantive Positivism and the Idea of Crime." *Rationality and Society* 2, no. 4 (1990): 412–28.

Hobbes, Thomas, and J. C. A. Gaskin. *Leviathan,* Oxford World's Classics. Oxford: Oxford University Press, 1996.

Newburn, Tim. *Criminology.* Cullompton, UK: Willan, 2007.

Piquero, Alex R. "A General Theory of Crime and Public Policy." In *Criminology and Public Policy,* edited by Hugh D. Barlow and Scott H. Decker, 66–83. Philadelphia: Temple University Press, 2010.

Piquero, Alex R., David P. Farrington, and Alfred Blumstein. "The Criminal Career Paradigm." *Crime and Justice* 30 (2003): 359–506.

Pratt, Travis C. "A Reconceptualized Model of Self-Control and Crime." *Criminal Justice and Behavior* 42, no. 6 (2015): 662–79.

Pratt, Travis C., and Francis T. Cullen. "The Empirical Status of Gottfredson and Hirschi's General Theory of Crime: A Meta-Analysis." *Criminology* 38, no. 3 (2000): 931–64.

Pratt, Travis C., Travis W. Franklin, and Jacinta M.Gau. "Key Idea: Hirschi's Social Bond/Social Control Theory." In *Key Ideas in Criminology and Criminal Justice,* 55–71. Thousand Oaks, CA: Sage Publications, Inc. 2011.

Rebellon, Cesar J., Murray A. Straus, and Rose Medeiros. "Self-control in Global Perspective: An Empirical Assessment of Gottfredson and Hirschi's General Theory within and across 32 National Settings." *European Journal of Criminology* 5, no. 3 (2008): 331–62.

"Ronald L. Akers, American criminologist." *Encyclopaedia Britannica*. Accessed December 14, 2015. http://www.britannica.com/biography/Ronald-L-Akers.

Schreck, Christopher J. "Hirschi, Travis." *The Encyclopedia of Theoretical Criminology.* New York: John Wiley & Sons, 2014.

Thorman, Lyndi. "Gottfredson, Michael." *The Encyclopedia of Theoretical Criminology.* New York: John Wiley & Sons, 2014.

THE MACAT LIBRARY
BY DISCIPLINE

AFRICANA STUDIES

Chinua Achebe's *An Image of Africa: Racism in Conrad's Heart of Darkness*
W. E. B. Du Bois's *The Souls of Black Folk*
Zora Neale Huston's *Characteristics of Negro Expression*
Martin Luther King Jr's *Why We Can't Wait*
Toni Morrison's *Playing in the Dark: Whiteness in the American Literary Imagination*

ANTHROPOLOGY

Arjun Appadurai's *Modernity at Large: Cultural Dimensions of Globalisation*
Philippe Ariès's *Centuries of Childhood*
Franz Boas's *Race, Language and Culture*
Kim Chan & Renée Mauborgne's *Blue Ocean Strategy*
Jared Diamond's *Guns, Germs & Steel: the Fate of Human Societies*
Jared Diamond's *Collapse: How Societies Choose to Fail or Survive*
E. E. Evans-Pritchard's *Witchcraft, Oracles and Magic Among the Azande*
James Ferguson's *The Anti-Politics Machine*
Clifford Geertz's *The Interpretation of Cultures*
David Graeber's *Debt: the First 5000 Years*
Karen Ho's *Liquidated: An Ethnography of Wall Street*
Geert Hofstede's *Culture's Consequences: Comparing Values, Behaviors, Institutes and Organizations across Nations*
Claude Lévi-Strauss's *Structural Anthropology*
Jay Macleod's *Ain't No Makin' It: Aspirations and Attainment in a Low-Income Neighborhood*
Saba Mahmood's *The Politics of Piety: The Islamic Revival and the Feminist Subjec*t
Marcel Mauss's *The Gift*

BUSINESS

Jean Lave & Etienne Wenger's *Situated Learning*
Theodore Levitt's *Marketing Myopia*
Burton G. Malkiel's *A Random Walk Down Wall Street*
Douglas McGregor's *The Human Side of Enterprise*
Michael Porter's *Competitive Strategy: Creating and Sustaining Superior Performance*
John Kotter's *Leading Change*
C. K. Prahalad & Gary Hamel's *The Core Competence of the Corporation*

CRIMINOLOGY

Michelle Alexander's *The New Jim Crow: Mass Incarceration in the Age of Colorblindness*
Michael R. Gottfredson & Travis Hirschi's *A General Theory of Crime*
Richard Herrnstein & Charles A. Murray's *The Bell Curve: Intelligence and Class Structure in American Life*
Elizabeth Loftus's *Eyewitness Testimony*
Jay Macleod's *Ain't No Makin' It: Aspirations and Attainment in a Low-Income Neighborhood*
Philip Zimbardo's *The Lucifer Effect*

ECONOMICS

Janet Abu-Lughod's *Before European Hegemony*
Ha-Joon Chang's *Kicking Away the Ladder*
David Brion Davis's *The Problem of Slavery in the Age of Revolution*
Milton Friedman's *The Role of Monetary Policy*
Milton Friedman's *Capitalism and Freedom*
David Graeber's *Debt: the First 5000 Years*
Friedrich Hayek's *The Road to Serfdom*
Karen Ho's *Liquidated: An Ethnography of Wall Street*

John Maynard Keynes's *The General Theory of Employment, Interest and Money*
Charles P. Kindleberger's *Manias, Panics and Crashes*
Robert Lucas's *Why Doesn't Capital Flow from Rich to Poor Countries?*
Burton G. Malkiel's *A Random Walk Down Wall Street*
Thomas Robert Malthus's *An Essay on the Principle of Population*
Karl Marx's *Capital*
Thomas Piketty's *Capital in the Twenty-First Century*
Amartya Sen's *Development as Freedom*
Adam Smith's *The Wealth of Nations*
Nassim Nicholas Taleb's *The Black Swan: The Impact of the Highly Improbable*
Amos Tversky's & Daniel Kahneman's *Judgment under Uncertainty: Heuristics and Biases*
Mahbub Ul Haq's *Reflections on Human Development*
Max Weber's *The Protestant Ethic and the Spirit of Capitalism*

FEMINISM AND GENDER STUDIES

Judith Butler's *Gender Trouble*
Simone De Beauvoir's *The Second Sex*
Michel Foucault's *History of Sexuality*
Betty Friedan's *The Feminine Mystique*
Saba Mahmood's *The Politics of Piety: The Islamic Revival and the Feminist Subjec*t
Joan Wallach Scott's *Gender and the Politics of History*
Mary Wollstonecraft's *A Vindication of the Rights of Woman*
Virginia Woolf's *A Room of One's Own*

GEOGRAPHY

The Brundtland Report's *Our Common Future*
Rachel Carson's *Silent Spring*
Charles Darwin's *On the Origin of Species*
James Ferguson's *The Anti-Politics Machine*
Jane Jacobs's *The Death and Life of Great American Cities*
James Lovelock's *Gaia: A New Look at Life on Earth*
Amartya Sen's *Development as Freedom*
Mathis Wackernagel & William Rees's *Our Ecological Footprint*

HISTORY

Janet Abu-Lughod's *Before European Hegemony*
Benedict Anderson's *Imagined Communities*
Bernard Bailyn's *The Ideological Origins of the American Revolution*
Hanna Batatu's *The Old Social Classes And The Revolutionary Movements Of Iraq*
Christopher Browning's *Ordinary Men: Reserve Police Batallion 101 and the Final Solution in Poland*
Edmund Burke's *Reflections on the Revolution in France*
William Cronon's *Nature's Metropolis: Chicago And The Great West*
Alfred W. Crosby's *The Columbian Exchange*
Hamid Dabashi's *Iran: A People Interrupted*
David Brion Davis's *The Problem of Slavery in the Age of Revolution*
Nathalie Zemon Davis's *The Return of Martin Guerre*
Jared Diamond's *Guns, Germs & Steel: the Fate of Human Societies*
Frank Dikotter's *Mao's Great Famine*
John W Dower's *War Without Mercy: Race And Power In The Pacific War*
W. E. B. Du Bois's *The Souls of Black Folk*
Richard J. Evans's *In Defence of History*
Lucien Febvre's *The Problem of Unbelief in the 16th Century*
Sheila Fitzpatrick's *Everyday Stalinism*

The Macat Library By Discipline

Eric Foner's *Reconstruction: America's Unfinished Revolution, 1863-1877*
Michel Foucault's *Discipline and Punish*
Michel Foucault's *History of Sexuality*
Francis Fukuyama's *The End of History and the Last Man*
John Lewis Gaddis's *We Now Know: Rethinking Cold War History*
Ernest Gellner's *Nations and Nationalism*
Eugene Genovese's *Roll, Jordan, Roll: The World the Slaves Made*
Carlo Ginzburg's *The Night Battles*
Daniel Goldhagen's *Hitler's Willing Executioners*
Jack Goldstone's *Revolution and Rebellion in the Early Modern World*
Antonio Gramsci's *The Prison Notebooks*
Alexander Hamilton, John Jay & James Madison's *The Federalist Papers*
Christopher Hill's *The World Turned Upside Down*
Carole Hillenbrand's *The Crusades: Islamic Perspectives*
Thomas Hobbes's *Leviathan*
Eric Hobsbawm's *The Age Of Revolution*
John A. Hobson's *Imperialism: A Study*
Albert Hourani's *History of the Arab Peoples*
Samuel P. Huntington's *The Clash of Civilizations and the Remaking of World Order*
C. L. R. James's *The Black Jacobins*
Tony Judt's *Postwar: A History of Europe Since 1945*
Ernst Kantorowicz's *The King's Two Bodies: A Study in Medieval Political Theology*
Paul Kennedy's *The Rise and Fall of the Great Powers*
Ian Kershaw's *The "Hitler Myth": Image and Reality in the Third Reich*
John Maynard Keynes's *The General Theory of Employment, Interest and Money*
Charles P. Kindleberger's *Manias, Panics and Crashes*
Martin Luther King Jr's *Why We Can't Wait*
Henry Kissinger's *World Order: Reflections on the Character of Nations and the Course of History*
Thomas Kuhn's *The Structure of Scientific Revolutions*
Georges Lefebvre's *The Coming of the French Revolution*
John Locke's *Two Treatises of Government*
Niccolò Machiavelli's *The Prince*
Thomas Robert Malthus's *An Essay on the Principle of Population*
Mahmood Mamdani's *Citizen and Subject: Contemporary Africa And The Legacy Of Late Colonialism*
Karl Marx's *Capital*
Stanley Milgram's *Obedience to Authority*
John Stuart Mill's *On Liberty*
Thomas Paine's *Common Sense*
Thomas Paine's *Rights of Man*
Geoffrey Parker's *Global Crisis: War, Climate Change and Catastrophe in the Seventeenth Century*
Jonathan Riley-Smith's *The First Crusade and the Idea of Crusading*
Jean-Jacques Rousseau's *The Social Contract*
Joan Wallach Scott's *Gender and the Politics of History*
Theda Skocpol's *States and Social Revolutions*
Adam Smith's *The Wealth of Nations*
Timothy Snyder's *Bloodlands: Europe Between Hitler and Stalin*
Sun Tzu's *The Art of War*
Keith Thomas's *Religion and the Decline of Magic*
Thucydides's *The History of the Peloponnesian War*
Frederick Jackson Turner's *The Significance of the Frontier in American History*
Odd Arne Westad's *The Global Cold War: Third World Interventions And The Making Of Our Times*

LITERATURE

Chinua Achebe's *An Image of Africa: Racism in Conrad's Heart of Darkness*
Roland Barthes's *Mythologies*
Homi K. Bhabha's *The Location of Culture*
Judith Butler's *Gender Trouble*
Simone De Beauvoir's *The Second Sex*
Ferdinand De Saussure's *Course in General Linguistics*
T. S. Eliot's *The Sacred Wood: Essays on Poetry and Criticism*
Zora Neale Huston's *Characteristics of Negro Expression*
Toni Morrison's *Playing in the Dark: Whiteness in the American Literary Imagination*
Edward Said's *Orientalism*
Gayatri Chakravorty Spivak's *Can the Subaltern Speak?*
Mary Wollstonecraft's *A Vindication of the Rights of Women*
Virginia Woolf's *A Room of One's Own*

PHILOSOPHY

Elizabeth Anscombe's *Modern Moral Philosophy*
Hannah Arendt's *The Human Condition*
Aristotle's *Metaphysics*
Aristotle's *Nicomachean Ethics*
Edmund Gettier's *Is Justified True Belief Knowledge?*
Georg Wilhelm Friedrich Hegel's *Phenomenology of Spirit*
David Hume's *Dialogues Concerning Natural Religion*
David Hume's *The Enquiry for Human Understanding*
Immanuel Kant's *Religion within the Boundaries of Mere Reason*
Immanuel Kant's *Critique of Pure Reason*
Søren Kierkegaard's *The Sickness Unto Death*
Søren Kierkegaard's *Fear and Trembling*
C. S. Lewis's *The Abolition of Man*
Alasdair MacIntyre's *After Virtue*
Marcus Aurelius's *Meditations*
Friedrich Nietzsche's *On the Genealogy of Morality*
Friedrich Nietzsche's *Beyond Good and Evil*
Plato's *Republic*
Plato's *Symposium*
Jean-Jacques Rousseau's *The Social Contract*
Gilbert Ryle's *The Concept of Mind*
Baruch Spinoza's *Ethics*
Sun Tzu's *The Art of War*
Ludwig Wittgenstein's *Philosophical Investigations*

POLITICS

Benedict Anderson's *Imagined Communities*
Aristotle's *Politics*
Bernard Bailyn's *The Ideological Origins of the American Revolution*
Edmund Burke's *Reflections on the Revolution in France*
John C. Calhoun's *A Disquisition on Government*
Ha-Joon Chang's *Kicking Away the Ladder*
Hamid Dabashi's *Iran: A People Interrupted*
Hamid Dabashi's *Theology of Discontent: The Ideological Foundation of the Islamic Revolution in Iran*
Robert Dahl's *Democracy and its Critics*
Robert Dahl's *Who Governs?*
David Brion Davis's *The Problem of Slavery in the Age of Revolution*

The Macat Library By Discipline

Alexis De Tocqueville's *Democracy in America*
James Ferguson's *The Anti-Politics Machine*
Frank Dikotter's *Mao's Great Famine*
Sheila Fitzpatrick's *Everyday Stalinism*
Eric Foner's *Reconstruction: America's Unfinished Revolution, 1863-1877*
Milton Friedman's *Capitalism and Freedom*
Francis Fukuyama's *The End of History and the Last Man*
John Lewis Gaddis's *We Now Know: Rethinking Cold War History*
Ernest Gellner's *Nations and Nationalism*
David Graeber's *Debt: the First 5000 Years*
Antonio Gramsci's *The Prison Notebooks*
Alexander Hamilton, John Jay & James Madison's *The Federalist Papers*
Friedrich Hayek's *The Road to Serfdom*
Christopher Hill's *The World Turned Upside Down*
Thomas Hobbes's *Leviathan*
John A. Hobson's *Imperialism: A Study*
Samuel P. Huntington's *The Clash of Civilizations and the Remaking of World Order*
Tony Judt's *Postwar: A History of Europe Since 1945*
David C. Kang's *China Rising: Peace, Power and Order in East Asia*
Paul Kennedy's *The Rise and Fall of Great Powers*
Robert Keohane's *After Hegemony*
Martin Luther King Jr.'s *Why We Can't Wait*
Henry Kissinger's *World Order: Reflections on the Character of Nations and the Course of History*
John Locke's *Two Treatises of Government*
Niccolò Machiavelli's *The Prince*
Thomas Robert Malthus's *An Essay on the Principle of Population*
Mahmood Mamdani's *Citizen and Subject: Contemporary Africa And The Legacy Of Late Colonialism*
Karl Marx's *Capital*
John Stuart Mill's *On Liberty*
John Stuart Mill's *Utilitarianism*
Hans Morgenthau's *Politics Among Nations*
Thomas Paine's *Common Sense*
Thomas Paine's *Rights of Man*
Thomas Piketty's *Capital in the Twenty-First Century*
Robert D. Putman's *Bowling Alone*
John Rawls's *Theory of Justice*
Jean-Jacques Rousseau's *The Social Contract*
Theda Skocpol's *States and Social Revolutions*
Adam Smith's *The Wealth of Nations*
Sun Tzu's *The Art of War*
Henry David Thoreau's *Civil Disobedience*
Thucydides's *The History of the Peloponnesian War*
Kenneth Waltz's *Theory of International Politics*
Max Weber's *Politics as a Vocation*
Odd Arne Westad's *The Global Cold War: Third World Interventions And The Making Of Our Times*

POSTCOLONIAL STUDIES

Roland Barthes's *Mythologies*
Frantz Fanon's *Black Skin, White Masks*
Homi K. Bhabha's *The Location of Culture*
Gustavo Gutiérrez's *A Theology of Liberation*
Edward Said's *Orientalism*
Gayatri Chakravorty Spivak's *Can the Subaltern Speak?*

PSYCHOLOGY

Gordon Allport's *The Nature of Prejudice*
Alan Baddeley & Graham Hitch's *Aggression: A Social Learning Analysis*
Albert Bandura's *Aggression: A Social Learning Analysis*
Leon Festinger's *A Theory of Cognitive Dissonance*
Sigmund Freud's *The Interpretation of Dreams*
Betty Friedan's *The Feminine Mystique*
Michael R. Gottfredson & Travis Hirschi's *A General Theory of Crime*
Eric Hoffer's *The True Believer: Thoughts on the Nature of Mass Movements*
William James's *Principles of Psychology*
Elizabeth Loftus's *Eyewitness Testimony*
A. H. Maslow's *A Theory of Human Motivation*
Stanley Milgram's *Obedience to Authority*
Steven Pinker's *The Better Angels of Our Nature*
Oliver Sacks's *The Man Who Mistook His Wife For a Hat*
Richard Thaler & Cass Sunstein's *Nudge: Improving Decisions About Health, Wealth and Happiness*
Amos Tversky's *Judgment under Uncertainty: Heuristics and Biases*
Philip Zimbardo's *The Lucifer Effect*

SCIENCE

Rachel Carson's *Silent Spring*
William Cronon's *Nature's Metropolis: Chicago And The Great West*
Alfred W. Crosby's *The Columbian Exchange*
Charles Darwin's *On the Origin of Species*
Richard Dawkin's *The Selfish Gene*
Thomas Kuhn's *The Structure of Scientific Revolutions*
Geoffrey Parker's *Global Crisis: War, Climate Change and Catastrophe in the Seventeenth Century*
Mathis Wackernagel & William Rees's *Our Ecological Footprint*

SOCIOLOGY

Michelle Alexander's *The New Jim Crow: Mass Incarceration in the Age of Colorblindness*
Gordon Allport's *The Nature of Prejudice*
Albert Bandura's *Aggression: A Social Learning Analysis*
Hanna Batatu's *The Old Social Classes And The Revolutionary Movements Of Iraq*
Ha-Joon Chang's *Kicking Away the Ladder*
W. E. B. Du Bois's *The Souls of Black Folk*
Émile Durkheim's *On Suicide*
Frantz Fanon's *Black Skin, White Masks*
Frantz Fanon's *The Wretched of the Earth*
Eric Foner's *Reconstruction: America's Unfinished Revolution, 1863-1877*
Eugene Genovese's *Roll, Jordan, Roll: The World the Slaves Made*
Jack Goldstone's *Revolution and Rebellion in the Early Modern World*
Antonio Gramsci's *The Prison Notebooks*
Richard Herrnstein & Charles A Murray's *The Bell Curve: Intelligence and Class Structure in American Life*
Eric Hoffer's *The True Believer: Thoughts on the Nature of Mass Movements*
Jane Jacobs's *The Death and Life of Great American Cities*
Robert Lucas's *Why Doesn't Capital Flow from Rich to Poor Countries?*
Jay Macleod's *Ain't No Makin' It: Aspirations and Attainment in a Low Income Neighborhood*
Elaine May's *Homeward Bound: American Families in the Cold War Era*
Douglas McGregor's *The Human Side of Enterprise*
C. Wright Mills's *The Sociological Imagination*

Thomas Piketty's *Capital in the Twenty-First Century*
Robert D. Putman's *Bowling Alone*
David Riesman's *The Lonely Crowd: A Study of the Changing American Character*
Edward Said's *Orientalism*
Joan Wallach Scott's *Gender and the Politics of History*
Theda Skocpol's *States and Social Revolutions*
Max Weber's *The Protestant Ethic and the Spirit of Capitalism*

THEOLOGY

Augustine's *Confessions*
Benedict's *Rule of St Benedict*
Gustavo Gutiérrez's *A Theology of Liberation*
Carole Hillenbrand's *The Crusades: Islamic Perspectives*
David Hume's *Dialogues Concerning Natural Religion*
Immanuel Kant's *Religion within the Boundaries of Mere Reason*
Ernst Kantorowicz's *The King's Two Bodies: A Study in Medieval Political Theology*
Søren Kierkegaard's *The Sickness Unto Death*
C. S. Lewis's *The Abolition of Man*
Saba Mahmood's *The Politics of Piety: The Islamic Revival and the Feminist Subject*
Baruch Spinoza's *Ethics*
Keith Thomas's *Religion and the Decline of Magic*

COMING SOON

Chris Argyris's *The Individual and the Organisation*
Seyla Benhabib's *The Rights of Others*
Walter Benjamin's *The Work Of Art in the Age of Mechanical Reproduction*
John Berger's *Ways of Seeing*
Pierre Bourdieu's *Outline of a Theory of Practice*
Mary Douglas's *Purity and Danger*
Roland Dworkin's *Taking Rights Seriously*
James G. March's *Exploration and Exploitation in Organisational Learning*
Ikujiro Nonaka's *A Dynamic Theory of Organizational Knowledge Creation*
Griselda Pollock's *Vision and Difference*
Amartya Sen's *Inequality Re-Examined*
Susan Sontag's *On Photography*
Yasser Tabbaa's *The Transformation of Islamic Art*
Ludwig von Mises's *Theory of Money and Credit*

Macat Disciplines

Access the greatest ideas and thinkers across entire disciplines, including

AFRICANA STUDIES

Chinua Achebe's *An Image of Africa: Racism in Conrad's Heart of Darkness*

W. E. B. Du Bois's *The Souls of Black Folk*

Zora Neale Hurston's *Characteristics of Negro Expression*

Martin Luther King Jr.'s *Why We Can't Wait*

Toni Morrison's *Playing in the Dark: Whiteness in the American Literary Imagination*

Macat analyses are available from all good bookshops and libraries.

Access hundreds of analyses through one, multimedia tool.

Join free for one month **library.macat.com**

Macat Disciplines

Access the greatest ideas and thinkers across entire disciplines, including

FEMINISM, GENDER AND QUEER STUDIES

Simone De Beauvoir's
The Second Sex

Michel Foucault's
History of Sexuality

Betty Friedan's
The Feminine Mystique

Saba Mahmood's
*The Politics of Piety:
The Islamic Revival and
the Feminist Subject*

Joan Wallach Scott's
*Gender and the
Politics of History*

Mary Wollstonecraft's
*A Vindication of the
Rights of Woman*

Virginia Woolf's
A Room of One's Own

Judith Butler's
Gender Trouble

Macat analyses are available from all good bookshops and libraries.

Access hundreds of analyses through one, multimedia tool.
Join free for one month **library.macat.com**

Macat Disciplines

Access the greatest ideas and thinkers across entire disciplines, including

INEQUALITY

Ha-Joon Chang's, *Kicking Away the Ladder*

David Graeber's, *Debt: The First 5000 Years*

Robert E. Lucas's, *Why Doesn't Capital Flow from Rich To Poor Countries?*

Thomas Piketty's, *Capital in the Twenty-First Century*

Amartya Sen's, *Inequality Re-Examined*

Mahbub Ul Haq's, *Reflections on Human Development*

Macat analyses are available from all good bookshops and libraries.

Access hundreds of analyses through one, multimedia tool.

Join free for one month **library.macat.com**

Macat Disciplines

Access the greatest ideas and thinkers across entire disciplines, including

CRIMINOLOGY

Michelle Alexander's
*The New Jim Crow:
Mass Incarceration in the
Age of Colorblindness*

**Michael R. Gottfredson
& Travis Hirschi's**
A General Theory of Crime

Elizabeth Loftus's
Eyewitness Testimony

**Richard Herrnstein
& Charles A. Murray's**
*The Bell Curve: Intelligence and
Class Structure in American Life*

Jay Macleod's
*Ain't No Makin' It:
Aspirations and Attainment in a
Low-Income Neighborhood*

Philip Zimbardo's
The Lucifer Effect

Macat analyses are available from all good bookshops and libraries.

Access hundreds of analyses through one, multimedia tool.
Join free for one month **library.macat.com**

Macat Disciplines

Access the greatest ideas and thinkers across entire disciplines, including

Postcolonial Studies

Roland Barthes's *Mythologies*
Frantz Fanon's *Black Skin, White Masks*
Homi K. Bhabha's *The Location of Culture*
Gustavo Gutiérrez's *A Theology of Liberation*
Edward Said's *Orientalism*
Gayatri Chakravorty Spivak's *Can the Subaltern Speak?*

Macat analyses are available from all good bookshops and libraries.

Access hundreds of analyses through one, multimedia tool.

Join free for one month **library.macat.com**

Macat Disciplines

Access the greatest ideas and thinkers across entire disciplines, including

GLOBALIZATION

Arjun Appadurai's, *Modernity at Large: Cultural Dimensions of Globalisation*

James Ferguson's, *The Anti-Politics Machine*

Geert Hofstede's, *Culture's Consequences*

Amartya Sen's, *Development as Freedom*

Macat analyses are available from all good bookshops and libraries.

Access hundreds of analyses through one, multimedia tool.
Join free for one month **library.macat.com**

Macat Pairs

Analyse historical and modern issues from opposite sides of an argument. Pairs include:

HOW TO RUN AN ECONOMY

John Maynard Keynes's
The General Theory OF Employment, Interest and Money

Classical economics suggests that market economies are self-correcting in times of recession or depression, and tend toward full employment and output. But English economist John Maynard Keynes disagrees.

In his ground-breaking 1936 study *The General Theory*, Keynes argues that traditional economics has misunderstood the causes of unemployment. Employment is not determined by the price of labor; it is directly linked to demand. Keynes believes market economies are by nature unstable, and so require government intervention. Spurred on by the social catastrophe of the Great Depression of the 1930s, he sets out to revolutionize the way the world thinks

Milton Friedman's
The Role of Monetary Policy

Friedman's 1968 paper changed the course of economic theory. In just 17 pages, he demolished existing theory and outlined an effective alternate monetary policy designed to secure 'high employment, stable prices and rapid growth.'

Friedman demonstrated that monetary policy plays a vital role in broader economic stability and argued that economists got their monetary policy wrong in the 1950s and 1960s by misunderstanding the relationship between inflation and unemployment. Previous generations of economists had believed that governments could permanently decrease unemployment by permitting inflation—and vice versa. Friedman's most original contribution was to show that this supposed trade-off is an illusion that only works in the short term.

Macat analyses are available from all good bookshops and libraries.

Access hundreds of analyses through one, multimedia tool.
Join free for one month **library.macat.com**

Macat Disciplines

*Access the greatest ideas and thinkers
across entire disciplines, including*

THE FUTURE OF DEMOCRACY

Robert A. Dahl's, *Democracy and Its Critics*
Robert A. Dahl's, *Who Governs?*
Alexis De Toqueville's, *Democracy in America*
Niccolò Machiavelli's, *The Prince*
John Stuart Mill's, *On Liberty*
Robert D. Putnam's, *Bowling Alone*
Jean-Jacques Rousseau's, *The Social Contract*
Henry David Thoreau's, *Civil Disobedience*

Macat Pairs

Analyse historical and modern issues from opposite sides of an argument. Pairs include:

INTERNATIONAL RELATIONS IN THE 21ST CENTURY

Samuel P. Huntington's
The Clash of Civilisations

In his highly influential 1996 book, Huntington offers a vision of a post-Cold War world in which conflict takes place not between competing ideologies but between cultures. The worst clash, he argues, will be between the Islamic world and the West: the West's arrogance and belief that its culture is a "gift" to the world will come into conflict with Islam's obstinacy and concern that its culture is under attack from a morally decadent "other."

Clash inspired much debate between different political schools of thought. But its greatest impact came in helping define American foreign policy in the wake of the 2001 terrorist attacks in New York and Washington.

Francis Fukuyama's
The End of History and the Last Man

Published in 1992, *The End of History and the Last Man* argues that capitalist democracy is the final destination for all societies. Fukuyama believed democracy triumphed during the Cold War because it lacks the "fundamental contradictions" inherent in communism and satisfies our yearning for freedom and equality. Democracy therefore marks the endpoint in the evolution of ideology, and so the "end of history." There will still be "events," but no fundamental change in ideology.

Macat Disciplines

Access the greatest ideas and thinkers across entire disciplines, including

MAN AND THE ENVIRONMENT

The Brundtland Report's, *Our Common Future*
Rachel Carson's, *Silent Spring*
James Lovelock's, *Gaia: A New Look at Life on Earth*
Mathis Wackernagel & William Rees's, *Our Ecological Footprint*

Macat analyses are available from all good bookshops and libraries.

Access hundreds of analyses through one, multimedia tool.
Join free for one month **library.macat.com**

Macat Pairs

*Analyse historical and modern issues
from opposite sides of an argument.
Pairs include:*

ARE WE FUNDAMENTALLY GOOD - OR BAD?

Steven Pinker's
The Better Angels of Our Nature

Stephen Pinker's gloriously optimistic 2011 book argues that, despite humanity's biological tendency toward violence, we are, in fact, less violent today than ever before. To prove his case, Pinker lays out pages of detailed statistical evidence. For him, much of the credit for the decline goes to the eighteenth-century Enlightenment movement, whose ideas of liberty, tolerance, and respect for the value of human life filtered down through society and affected how people thought. That psychological change led to behavioral change—and overall we became more peaceful. Critics countered that humanity could never overcome the biological urge toward violence; others argued that Pinker's statistics were flawed.

Philip Zimbardo's
The Lucifer Effect

Some psychologists believe those who commit cruelty are innately evil. Zimbardo disagrees. In *The Lucifer Effect*, he argues that sometimes good people do evil things simply because of the situations they find themselves in, citing many historical examples to illustrate his point. Zimbardo details his 1971 Stanford prison experiment, where ordinary volunteers playing guards in a mock prison rapidly became abusive. But he also describes the tortures committed by US army personnel in Iraq's Abu Ghraib prison in 2003—and how he himself testified in defence of one of those guards. committed by US army personnel in Iraq's Abu Ghraib prison in 2003—and how he himself testified in defence of one of those guards.

Macat Pairs

Analyse historical and modern issues from opposite sides of an argument. Pairs include:

HOW WE RELATE TO EACH OTHER AND SOCIETY

Jean-Jacques Rousseau's
The Social Contract

Rousseau's famous work sets out the radical concept of the 'social contract': a give-and-take relationship between individual freedom and social order.

If people are free to do as they like, governed only by their own sense of justice, they are also vulnerable to chaos and violence. To avoid this, Rousseau proposes, they should agree to give up some freedom to benefit from the protection of social and political organization. But this deal is only just if societies are led by the collective needs and desires of the people, and able to control the private interests of individuals. For Rousseau, the only legitimate form of government is rule by the people.

Robert D. Putnam's
Bowling Alone

In *Bowling Alone*, Robert Putnam argues that Americans have become disconnected from one another and from the institutions of their common life, and investigates the consequences of this change.

Looking at a range of indicators, from membership in formal organizations to the number of invitations being extended to informal dinner parties, Putnam demonstrates that Americans are interacting less and creating less "social capital" – with potentially disastrous implications for their society.

It would be difficult to overstate the impact of *Bowling Alone*, one of the most frequently cited social science publications of the last half-century.

Macat analyses are available from all good bookshops and libraries.

Access hundreds of analyses through one, multimedia tool.
Join free for one month **library.macat.com**